LEGENDARY

OF

CLEVELAND

OHIO

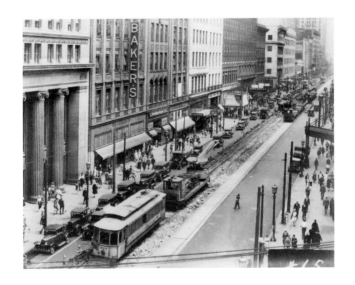

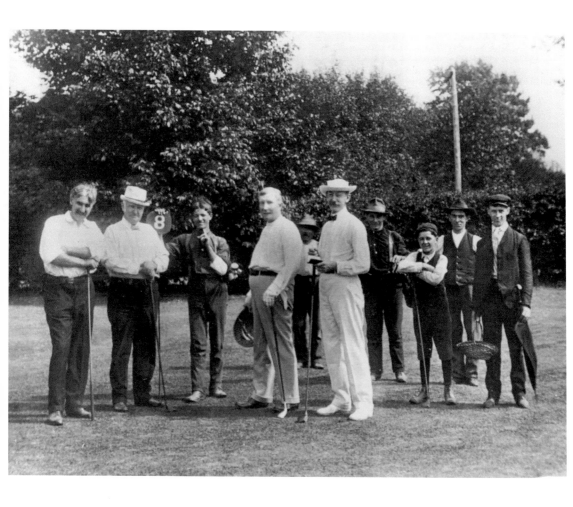

Page 1: Euclid Avenue
Euclid Avenue was the main street in Cleveland, extending east from Public Square to University Circle at East 105th Street. In Cleveland's heyday, Euclid was lined with department stores, theaters, banks, restaurants, bookstores, churches, and even the mansions of millionaires. Streetcars dotted the urban landscape, bringing visitors to experience life in a world-class city. (Cleveland Press Special Collections.)

Page 2: John D. Rockefeller and Friends
America's first millionaire and Cleveland's most famous citizen, John D. Rockefeller, made his fortune in the oil business. Here Rockefeller (with hat in hand) is joined on his Forest Hills estate golf course by, from left to right in the front row, Rev. Charles Eaton, Dr. Hamilton Fisk Biggar, and William Rudd of Chandler and Rudd Grocery. (Courtesy of Special Collections at Cleveland State University.)

LEGENDARY LOCALS

OF

CLEVELAND

OHIO

THEA GALLO BECKER

LEGENDARY
LOCALS

Legendary Locals is an imprint of Arcadia Publishing
Charleston, South Carolina

Printed in the United States of America

Library of Congress Control Number: 2012934812

For all general information, please contact Arcadia Publishing:
Telephone 843-853-2070
Fax 843-853-0044
E-mail sales@arcadiapublishing.com
For customer service and orders:
Toll-Free 1-888-313-2665

Visit us on the Internet at www.arcadiapublishing.com

Dedication
To my daughter Thealexa.
You have my respect and my love, always.

On the Cover: From left to right:
(TOP ROW) Almeda C. Adams, musician; Benjamin O. Davis, retired general; Bernice Goetz, explorer; Billy Bass, radio disc jockey; Clara Westropp, banker;
(MIDDLE ROW) Doris O'Donnell, journalist; Frederick C. Crawford, businessman; Florence Allen, jurist; Ernest Ball, singer/songwriter; Hazel Mountain Walker, educator;
(BOTTOM ROW) Lillian Andrews, political activist; Paige Palmer, fitness guru; Ray Chapman, Cleveland Indians ballplayer; Roberta Bole, philanthropist; and Zelma Watson George, United Nations delegate.
(All cover images courtesy of Special Collections at Cleveland State University.)

CONTENTS

ACKNOWLEDGMENTS

The photographs used in this book, except where indicated with courtesy lines, were obtained from the Special Collections area at the Michael Schwartz Library, Cleveland State University. The remaining images were used with the permission of the Cleveland Public Library Photograph Collection, an excellent repository with very helpful staff. Many thanks for all the help provided by the staff at CSU who allowed me to select the best images possible of individuals who greatly impacted Cleveland's history. The CSU Special Collections area has an outstanding selection of images and newspaper clippings from the *Cleveland Press*. Many of these images may be found on the Cleveland Memory website at clevelandmemory.org.

I found several books useful for researching Cleveland's history: *The Encyclopedia of Cleveland History* and *The Dictionary of Cleveland Biography*, both edited by David Van Tassel and John J. Grabowski; *Cleveland: The Making of a City* by William Ganson Rose; *Yesterday's Cleveland* by George E. Condon; and *Cleveland: A Concise History, 1796–1990*, by Carol Poh Miller and Robert Wheeler. Also useful were *The Plain Dealer* newspaper and the necrology file at the Cleveland Public Library.

Finally, I wish to extend my personal thanks and appreciation to Billy Bass, Doris O'Donnell, and Sherri Robertson, who took the time to speak with me about their lives and those regarded as legendary locals.

INTRODUCTION

Cleveland was founded in 1796 by Gen. Moses Cleaveland (1754–1806), who led a surveying party to explore the Western Reserve as an agent of the Connecticut Land Company. A native of Canterbury, Connecticut, General Cleaveland ranks first in *Legendary Locals of Cleveland*, as it was he who saw the vast potential of this region situated on the southern shores of Lake Erie in northeast Ohio. When Cleaveland landed at the mouth of the "crooked" Cuyahoga River, he was greeted by a lush territory he considered promising and on which he established a modest settlement that would honor his name. What began as a 10-acre New England–style public square grew into a village by 1815. Its first streets were named Superior and Ontario. In 1824, when the population surpassed 500, Cleveland began to emerge as a successful port of entry due to its prime lakefront location and bustling Public Square, the heart of downtown Cleveland. The talented, wealthy, and influential soon settled in the area, bringing their ideas and industry to build a city once called the New York of the Midwest. In 1836, the population of Cleveland topped 5,000 and the city was incorporated. With a population approaching one million at the beginning of the 20th century, Cleveland became a Great Lakes mecca attracting the most ambitious in business, industry, science, medicine, politics, and entertainment. Even those in the criminal world saw opportunity aplenty in Cleveland.

Legendary Locals of Cleveland is my third book on this city. Unlike the first two books, *Cleveland: 1796–1929* and *Cleveland: 1930–2000*, each of which chronicled the growth of the city through its infrastructure and featured only a few of the notable persons responsible for its development, this book focuses on those who lent their names, talent, wealth, industry, and passion to making Cleveland a city once ranked the sixth-largest in America. *Legendary Locals of Cleveland* attaches faces to the names of those who have appeared many times in various venues, and it introduces those who have had an impact but preferred to remain in the background and those who have simply disappeared from public view. Since Cleveland has a rich and dynamic history, narrowing the field of local legends to fewer than 200 people was not an easy task. So many have contributed to Cleveland's development and prosperity that striking a balance between obvious legends like former mayor Newton D. Baker and the more obscure ones like Anna "Newspaper Annie" Perkins, a female newsboy during the late 19th century, took some work. The result is a visual narrative celebrating some of the many memorable local individuals who have made Cleveland interesting over the years.

In six chapters, this book provides a brief history of the fascinating people, some of whom were locals and others who adopted Cleveland as their home, who contributed to the city's unique identity. The first chapter highlights the movers and the shakers—mainly business and philanthropic types who helped build Cleveland's institutions and industries. From the prominent Mather family are Samuel and William G., who helped make Cleveland a giant in the steel industry and who contributed to University Hospitals and the Cleveland Museum of Art. There is Dudley Blossom (for whom the summer home of the Cleveland Orchestra is named) and his association with John L. Severance, who helped build Severance Hall in University Circle. George Bellamy founded the Hiram settlement house, and Helen Horvath helped immigrants adjust to life in America. The automobile industry grew under the vision of people like Walter C. Baker and Alexander Winton and inventors like Marian Friend Chew, who made significant contributions toward improving automobile performance. And then there are innovators in the food industry who either introduced new products, like Vernon B. Stouffer and his frozen foods; had a new way to market food, like Manning Fisher; or who offered warm, inviting establishments to enjoy food and good company, like Ulysses S. Dearing and Otto Moser.

Cleveland has a remarkable history of legal, political, and criminal figures of legend. Among the outstanding jurists were Perry B. Jackson, Mary B. Grossman, and Florence E. Allen, each of whom distinguished themselves on the bench and served Cleveland well. On the other side were criminals like Cassie Chadwick, a turn-of-the-century con artist who fleeced the wealthy, and Louis "The Dip" Finkelstein, who picked pockets for a living. Cleveland had many social and political activists, including Chief Thunderwater, who fought to keep Erie Street Cemetery from destruction; Reverend Bruce Klunder, who became a martyr in the fight for school desegregation; and Lucia McBride, who worked tirelessly for equality for women in the voting booth and at work.

In the fields of science and medicine, University Hospitals and the world-renowned Cleveland Clinic, which Dr. George W. Crile helped found, firmly established the city's reputation as a leader in health care innovations. Dr. Claude S. Beck was a pioneering heart surgeon, and Dr. Irvine H. Page made significant contributions in the areas of high blood pressure and kidney dialysis. Dayton C. Miller helped use X-rays to get a closer look at our bodies, and Paul E. Leimkuehler refused to be limited by his disability and not only helped others with his work in prosthetics but developed a new way to ski. Frances P. Bolton was instrumental in turning nursing into a profession. Inventors like Garrett A. Morgan gave us the traffic light. Vincent G. Marrota, though not a household name, developed a product with instant name recognition: Mr. Coffee.

The fourth chapter highlights some of the greats as well as some who, to many Clevelanders, remain infamous. Businessman Art Modell, who took the team established by Mickey McBride, the Cleveland Browns, and moved to Baltimore, broke the city's heart. Baseball suffered tragedy when Ray Chapman died after taking a hit to the head during a game. But there were many triumphs, like boxing legend Johnny Kilbane's championship win and the stellar career of Stella Walsh, who excelled as the greatest female athlete of her day.

The creative talent in Cleveland, musically, artistically, and on the stage, is truly legendary. Who is not familiar with the ballad *When Irish Eyes Are Smiling*, penned by Clevelander Ernest R. Ball? Any discussion of the Cleveland Orchestra would include conductors like George Szell and Robert Shaw and guest performances from pianists like Eunice Podis. Viktor Schreckengost is a familiar name in the art world, and Archibald Willard painted a piece more famous than his name, the *The Spirit of '76*. Finally, we acknowledge the father of Playhouse Square, Joseph Laronge.

The final chapter recognizes those who wrote books about Cleveland, like George Condon; those who hunted news stories, like Theodore Andrica and Doris O'Donnell; those who took the photographs, which this book, among other things, would have been lost without; and finally, people like Louis B. Seltzer, longtime editor of the *Cleveland Press*, who made sure the stories of Cleveland's local legends were told and preserved.

—Thea Gallo Becker

CHAPTER ONE

The Movers and Shakers of Cleveland

Every community began with a dream—the vision of a core group of individuals who decided the location was worth the risk and then put plans in motion to build a town. Cleveland began to take shape and flourish when the individuals herein moved into action. At one time, Cleveland was an industrial giant with a lakefront location ideal for a wide array of business and industry. Automobile manufacturing took hold as men like Alexander Winton and Claud Foster sought to shake things up and make Cleveland a motor city. As personal wealth accumulated, philanthropy was encouraged. People like George Bellamy, Helen Horvath, and Hazel Mountain Walker sought to help those most in need with shelter, education, or simply learning to adjust in a new homeland. Then there are the entrepreneurs who found new ways to make life easier or just to entertain. Vernon Stouffer introduced frozen foods to America. Lionel Pile founded Hough Bakeries, to the delight of everyone. Restaurant operator Otto Moser made a point of knowing everyone's name, and Ulysses Dearing made dining out a real treat. Women were prominent in building the city. The Westropp sisters, Clara and Lillian, distinguished themselves in law and in the financial world by founding their own bank. Lastly, there are those who wanted to preserve the beauty of Cleveland's landscape and natural resources, like William Stinchcomb, who founded the Cleveland Metroparks system; and Helen Nash and Roberta Bole, who did their part to preserve nature.

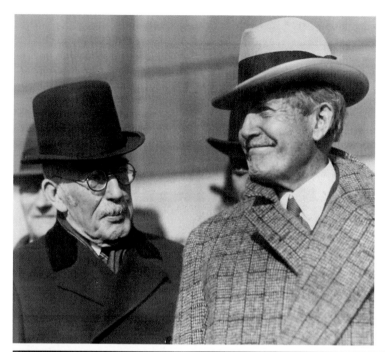

Samuel Mather and Myron T. Herrick
Samuel Mather (1851–1931) was a native Clevelander who headed one of the city's most influential and wealthy families. He amassed his fortune in the steel industry before turning his interests to philanthropy to benefit settlement homes like Hiram House, universities such as Western Reserve, and University Hospitals. He is pictured here in 1928 with Myron T. Herrick (right), the ambassador to France.

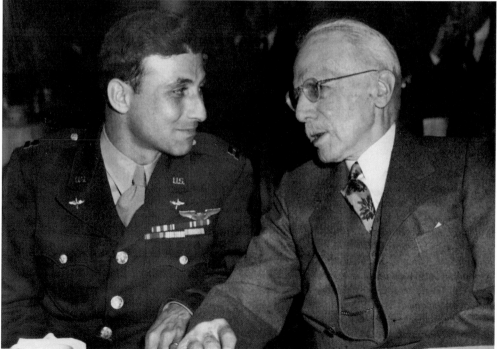

William G. Mather
Edmund Montagno (left) was a World War II flying ace who joined William Gwinn Mather (1857–1951) in 1943 for a war bond drive. Like his brother Samuel, William Mather was an industrialist and philanthropist. He was one of the founders of the Republic Steel Corp. and sat on the boards of the Cleveland Museum of Art, University Hospitals, and Case Western Reserve University.

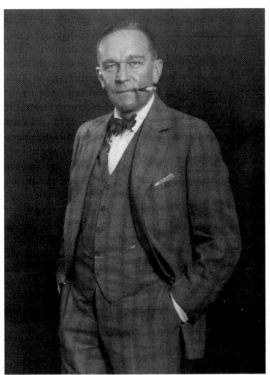

Dudley S. Blossom

Dudley Blossom (1879–1938) was a wealthy businessman, civic activist, and philanthropist. For two terms, 1919–1921 and 1924–1932, Blossom was Cleveland's welfare director and helped promote City Hospital, a charitable institution. He supported the cultural arts by contributing millions toward building Severance Hall, home of the Cleveland Orchestra. The summer home of the orchestra was named Blossom Music Center for him.

John L. Severance

Clevelander John Long Severance (1863–1936), wearing sunglasses while watching a polo match in 1932, was a wealthy industrialist and patron of the arts. His varied business interests included linseed oil and salt, and he used his fortune to help build Severance Hall as well as accumulate an impressive art collection, valued in the millions, which he willed to the Cleveland Museum of Art.

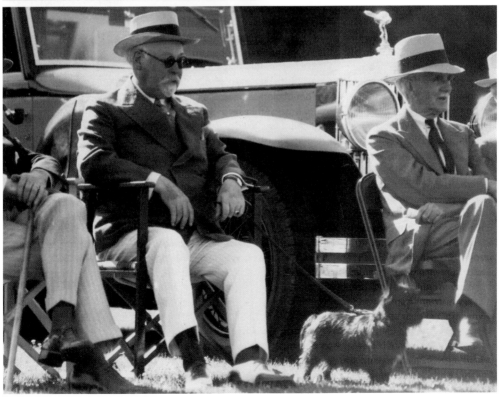

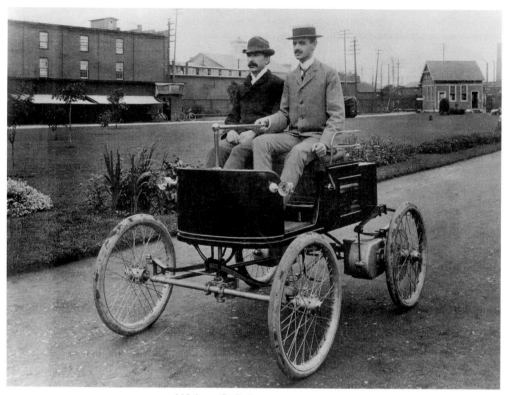

Walter C. Baker

Walter Baker (1868–1955) was an inventor and engineer who turned his passion for creating the ultimate horseless carriage into reality when, in 1898, he opened the Baker Motor Vehicle Company. Baker moved to Cleveland after his father, George, had relocated to help found the White Sewing Machine Company. Baker was interested in creating a better steering system for automobiles and building a car powered by electricity. He is seen here steering one of his automobiles, which he continued to produce until 1916.

Thomas H. White

Thomas White (1836–1914) was a successful businessman, inventor, and philanthropist. In 1866, he moved from Massachusetts to Cleveland to expand his new business, White Manufacturing Co., and mass-produce sewing machines. Ten years later, success led to the White Sewing Machine Co., putting Cleveland on the map as the sewing machine capital. White was also an extremely active philanthropist who donated to universities, charities, and the arts, and was active in civic affairs. (Cleveland Public Library Photograph Collection.)

Claud H. Foster
Claud Foster (1872–1965) was an automobile pioneer and philanthropist. In 1904, Foster, sitting tall in the backseat (far right), is chauffeured through New York City in an automobile equipped with his creation, the Gabriel Horn, which used exhaust gases to play a six-toned horn. The Gabriel Company then produced shock absorbers, which earned Foster huge profits, enabling him to donate to universities, hospitals, and many charities.

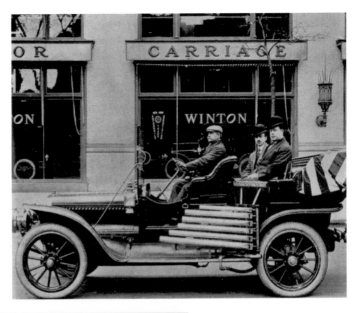

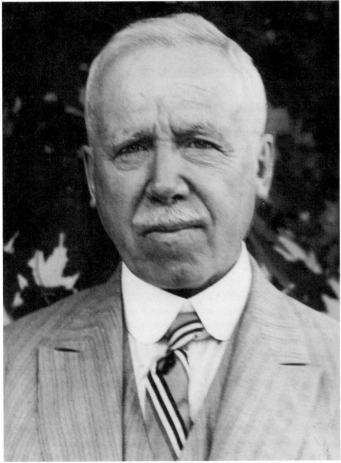

Alexander Winton
Alexander Winton (1860–1932) was another automotive pioneer. In 1884, he moved to Cleveland from his native Scotland and began his career building bicycles through the Winton Bicycle Company he founded in 1891. Within six years, he founded the Winton Motor Carriage Company to build his specialty cars. In 1912, Winton focused solely on engines and built the first American-made diesel engine.

13

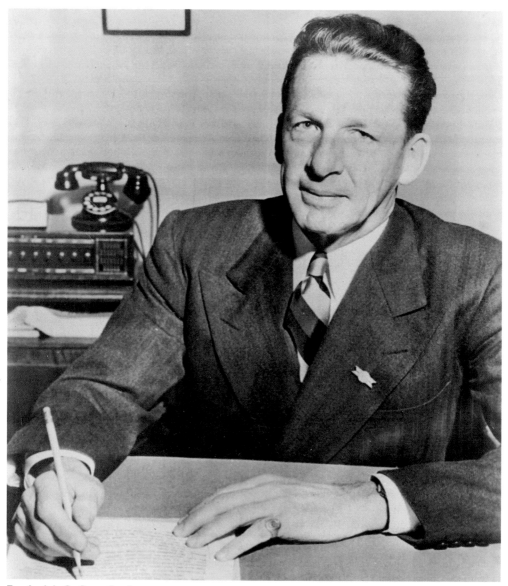

Frederick C. Crawford

Frederick Crawford (1891–1994) was an engineer turned wealthy businessman who spent a lifetime collecting vintage aircraft and automobiles, which he then donated to the Western Reserve Historical Society in 1963. In honor of his generosity and to complete his philanthropic will that the public should benefit from his interest in the history of transportation, the Frederick C. Crawford Auto Aviation Museum was built by and annexed to the historical society. Crawford had moved to Cleveland from Massachusetts and worked as a manager at Cleveland's Steel Products Co., the forerunner of Thompson Products Inc., of which he became president in 1933. Under Crawford's leadership, Thompson Inc. would bring the National Air Races and NASA to Cleveland. To house his growing collection of cars and planes, Crawford began the Thompson Auto and Aviation Museum in 1937. It was this collection that found a new home in the museum bearing his name. Crawford's philanthropy extended to Case Western Reserve University's science and engineering departments and the Cleveland Zoo, to which he also donated money and exotic animals.

Cyrus S. Eaton, Man of the World

Cyrus Eaton (1883–1979) was a billionaire industrialist, banker, financier, and philanthropist who, despite a devastating financial loss due to the Great Depression, managed to rebuild his wealth through the railroad and coal industries. Eaton left Canada for Cleveland and became a naturalized citizen in 1912. He chose Cleveland because of its lakefront location and natural resources, which he viewed as key to the city's greatness. After working for the East Ohio Gas Co. and the banking firm of Otis & Co., Eaton invested in coal, iron ore, and railroads and made a fortune. He used his wealth to help found the Cleveland Museum of Natural History and, later, Fenn College. Eaton also had a keen interest in foreign affairs and, during the Cold War, used his money and connections to help improve relations between the United States and the Soviet Union by sponsoring events designed to bring together the best in political and scientific fields.

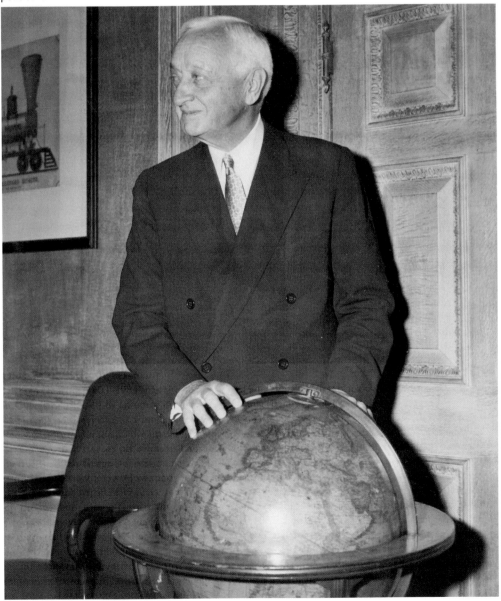

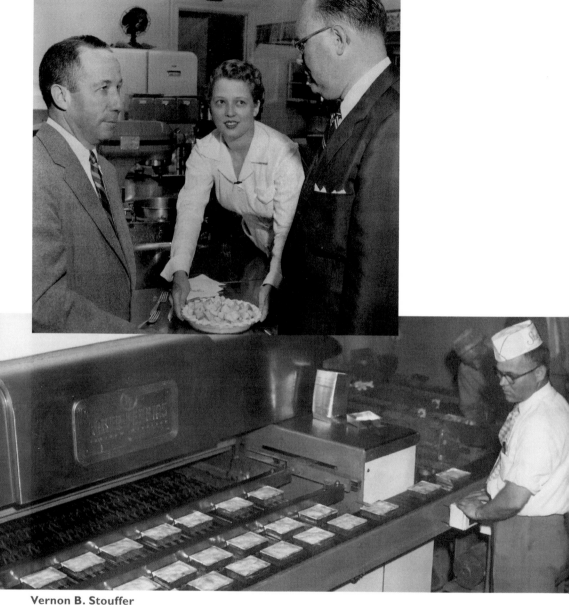

Vernon B. Stouffer

Vernon Stouffer (1901–1974) was the founder and CEO of the Stouffer Corporation, famous for its frozen foods. Stouffer's began in 1922 as a small family-run sandwich shop in Cleveland's Old Arcade. By 1924, Vernon Stouffer (top, left) took the lead in launching Stouffer's Lunch, a family restaurant. Good food and quick service made for a lucrative business and, in 1929, the Stouffer Corporation began. Restaurants were opened in major cities including New York and Chicago. Stouffer was active in all aspects of the company and built a frozen food kitchen on Woodland Avenue in Cleveland (above) to maintain the high standards he expected from any product bearing the name Stouffer. In order to give back to the community to which he attributed his success, the Vernon Stouffer Corporation, a charitable fund, was founded to donate to his many philanthropic interests.

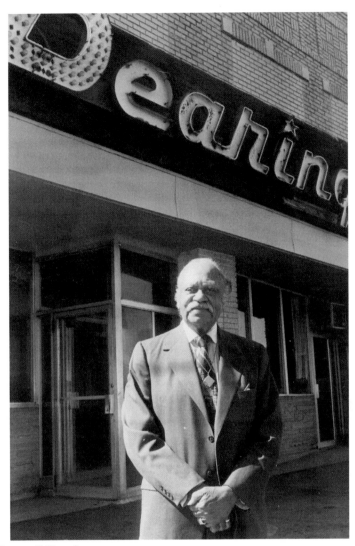

Ulysses S. "Sweets" Dearing

Ulysses Dearing (1903–1984) had the distinction of becoming the first black owner of a major restaurant in Cleveland. Raised by an uncle in rural Pennsylvania, Dearing sought to escape his impoverished life by moving to Cleveland as a teenager to find work. After a few years in the steelyards, he returned to Pennsylvania to pursue his dream of becoming a chef and owning his own restaurant. By the young age of 21, Dearing had started his own small business. Modest success followed until a flash flood ruined it all. By this time the Great Depression had also claimed many businesses, and Dearing decided to return to Cleveland to start anew. His experience as a cook and restaurant owner allowed Dearing to easily find work as a chef. After a few years, his hard work and expertise in the food business caught the attention of the owner of Cedar Gardens, a trendy nightclub on Cleveland's East Side, and Dearing was offered the position of manager. It was another dream-turned-reality as Dearing found himself in the company of some of the finest jazz singers and musicians of the age. After World War II, Dearing was ready to enter the restaurant business for a second time when, in 1946, he opened Dearing's at 1930 East 105th Street near University Circle. Success encouraged Dearing to open five more establishments, which also offered carry-out and catering services. His good food and warm demeanor made Dearing a millionaire. He used his wealth to give back to the city that gave so much to him.

Otto F. Moser

Otto Moser (1866–1942) was a nationally known Cleveland restaurateur whose café, originally located at 2044 East Fourth Street, once contained one of the largest private collections of theatrical photographs in the country. Born in Canton, Moser came to Cleveland as a child and lived with his family on Broadway Hill. In September 1892, Moser opened Otto Moser's Café on East Fourth Street, across from the old Opera House. He began his hobby of collecting autographed pictures of actors and actresses starting with performers from the Opera House and would display the photographs on the wall above his bar. Among the more familiar names were George M. Cohan, Eddie Foy, and Lillian Russell. Moser had opened his café as a meeting place during the golden age of drama. In the cellar of his café, a group of mostly actors and actresses would meet. Calling themselves the Cheese Club, they performed private shows for themselves, told stories, sang, and recited poetry, all the while drinking beer and eating cheese. Later, the Cheese Club expanded to include noted Cleveland families, political leaders, journalists, and those Moser called "the jolly good fellows" of the day. During Prohibition, Moser's café became a sandwich bar, the first of its kind in the country. By 1926, Otto Moser sandwich bars had opened nationwide. When Prohibition ended, Moser's re-opened the bar. Moser was kindly, tolerant, and honest, and he welcomed fellowship that came from his patrons and the club. *Cleveland Press* reporter George Davis wrote, "He was the same type of host as the old time hotel manager who made personal contacts with all his guests."

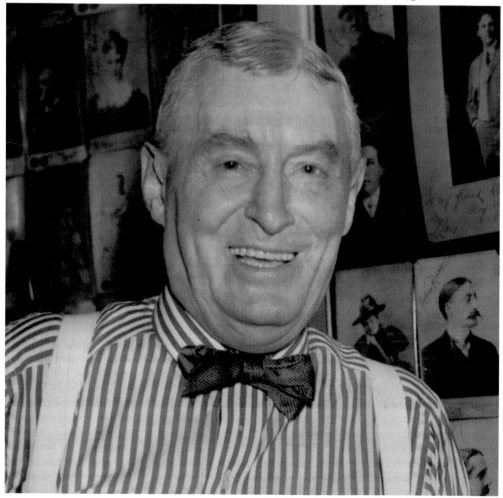

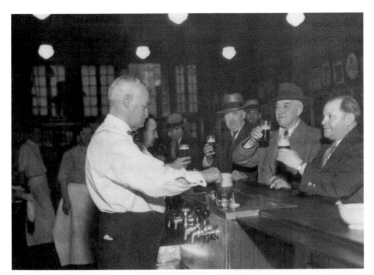

Inside Otto Moser's
In 1933, Otto Moser is serving, from left to right, James Burden, C.W. Hill, and Milton Upson. Moser prided himself on being the only café owner in Cleveland who did not use a cash register. He did not believe in them. At the end of an evening, the change was piled high in an uncounted heap on a marble slab behind the red mahogany bar. Paper money was kept in a large drawer.

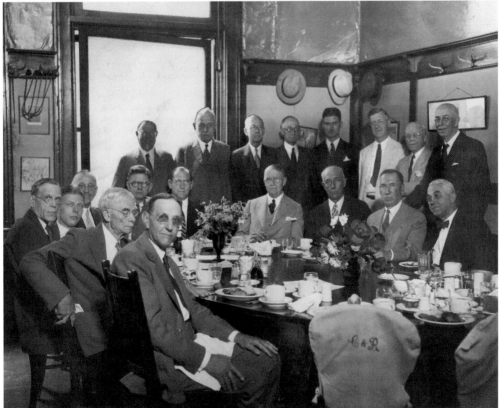

The Cheshire Cheese Club of Cleveland
The Cheshire Cheese Club met weekdays at the Chandler & Rudd Restaurant near the May Company on Public Square. It began in 1910 as a social club numbering an average of 40 members, including journalists, businessmen, artists, politicians, lawyers, and jurists who got into the habit of eating together and discussing important matters concerning Cleveland. A typical crowd was present on the day this photograph was taken in 1932.

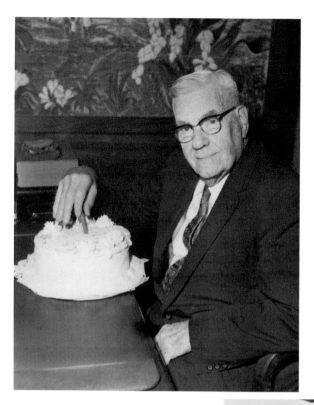

Lionel A. Pile
Lionel Archibald Pile (1879–1960) founded Hough Bakeries Inc. and Hough Caterers Inc. He came to Cleveland in 1902, worked in a grocery store, and made a down payment on a bakeshop at 8708 Hough Avenue using his savings of $57. His business grew to 55 stores and included a catering business and a frozen and prepared food section. At its peak, Hough Bakeries grossed $6 million annually.

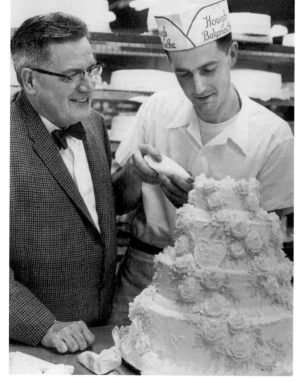

King Arthur and Hough Bakeries
Hough Bakeries was a family-owned-and-operated giant in the Cleveland baking and catering business. Arthur Pile Sr. (left) took over as head when his father, Lionel, died. Arthur Pile entered the business in the 1940s and helped Hough Caterers Inc. become Cleveland's society caterers. Here, Arthur Sr. watches his son, Arthur Jr., decorate a signature Hough wedding cake.

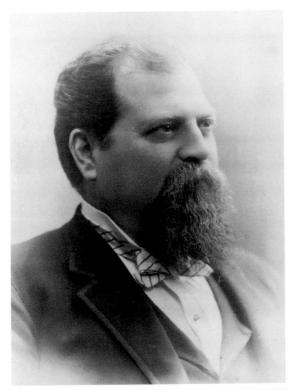

Isaac Leisy

Isaac Leisy (d. 1892) was one of three brothers who came to America in 1852 from Bavaria and established the Leisy Brewing Company. Originally located in Iowa, the company moved to Vega Avenue on the west side of Cleveland in 1872. Ten years later, Isaac gained sole ownership of the company when his brothers moved away. Isaac then undertook a number of significant renovations to improve the art of brewing high-quality beer and succeeded in making the Leisy Brewing Company not only Cleveland's premier brewery, but the premier brewery for all northeast Ohio at the time.

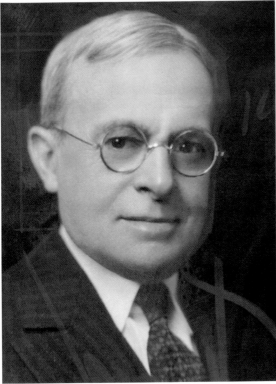

Manning F. Fisher

Manning Fisher (d. 1931) and his brother Charles moved to Cleveland in 1907 from New York City, where they had a modest grocery business. They established the Fisher Brothers Company and opened their first grocery store at 4623 Lorain Avenue on Cleveland's West Side. By 1916, Fisher Bros. had opened 48 stores, and by 1928 over 300 stores dotted northern Ohio, making Fisher Foods Cleveland's premier grocery chain.

Clara E. Westropp

Clevelander Clara Westropp (1886–1965) was a cofounder in 1922 of Women's Federal Savings & Loan Association with her sister Lillian. It was the first banking institution run by women specifically to involve women in financial affairs. Lillian had the ambition to undertake the independent organization of a women's financial institution, a bank of and by women for the general public. Lillian said, "We had to sell ourselves twice. Once, as an organization, and again as women." She promoted women in business. Lillian studied law when few women did and then ventured into finance, a field once taboo to women. It was difficult to sell the idea of women as financiers. Neither men nor women were keen for it. On February 1, 1922, Women's Federal opened with Clara as the secretary, treasurer, and manager of the company. Lillian was president of the bank. Lillian, Clara, and 13 other women comprised the board of directors, a first for any banking institution.

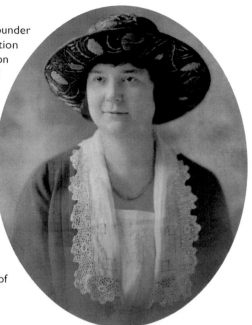

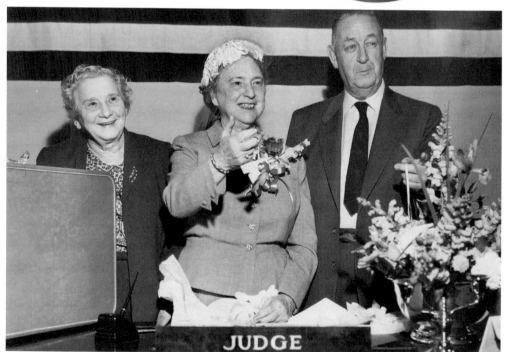

Lillian M. Westropp

Clevelander Lillian Westropp (1884–1968) served 25 years as a judge of Cleveland Municipal Court and was a cofounder with her sister Clara of Women's Federal Savings & Loan Association, one of the area's major financial institutions. She also was involved in politics, working for the Suffragette Party to secure the vote for women, and later helped found Democratic Women of Ohio and the League of Women Voters.

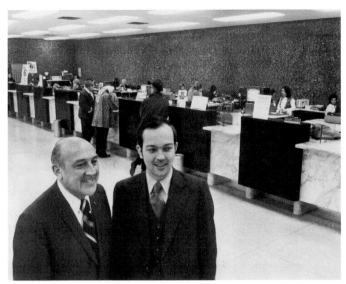

Ben S. Stefanski
Ben Stefanski (1902–1991) was a businessman and philanthropist who, in 1938, founded Third Federal Savings and Loan Association of Cleveland. As president and chairman of Third Federal, Stefanski wanted a banking institution that focused on the financial needs of the average American. He succeeded, and upon his retirement in 1987, there were 21 branches. His son Marc (pictured here) took over and expanded Third Federal to 22 branches.

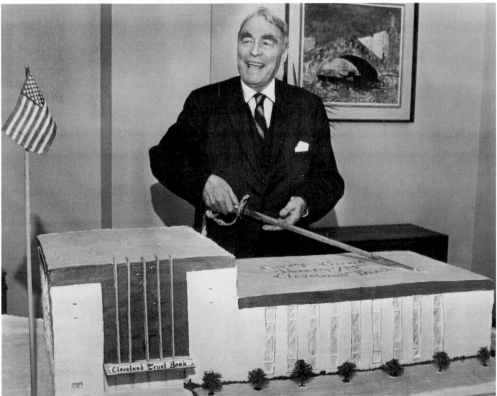

George Gund
George Gund (1888–1966) was a banker, financier, and philanthropist who led Cleveland Trust Bank from 1937 until his death. As director and then president of the bank, Gund steered Cleveland Trust, forerunner to Ameritrust, into the position of the preferred banking institution for many of the city's major businesses. Gund is seen here celebrating his 78th birthday by using a sword to cut a cake baked in the shape of the bank's 78th branch. (Photograph by Jerry Horton.)

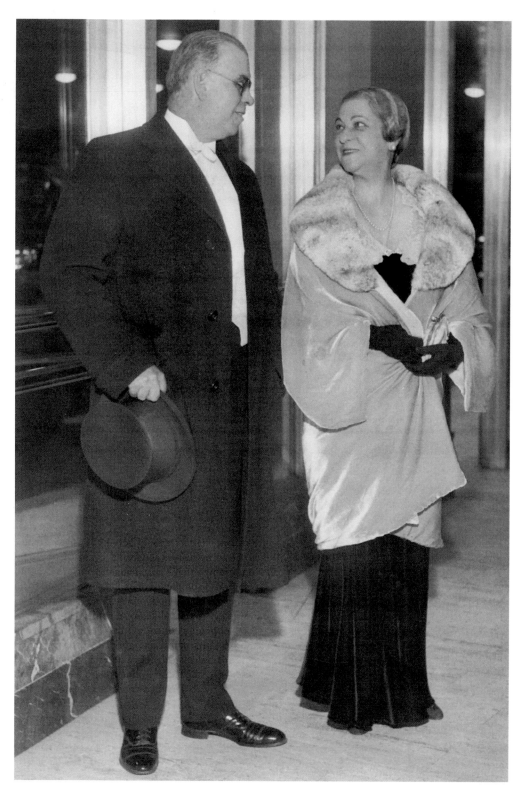

Frank Ray Walker (OPPOSITE)
Frank Walker (1877–1949) was half of the famed architectural firm known as Walker & Weeks, who designed many of Cleveland's prominent public buildings and landmarks. Frank Walker was the architect and designer who complemented Harry E. Weeks (1871–1935), who handled the business end of their partnership. In 1905, having worked as an architect in several major cities including New York and Boston, Walker moved to Cleveland and took a position with the architectural firm of J. Milton Dyer. At the same time, Weeks, with a similarly impressive background, had moved to Cleveland and joined Dyer's firm. In 1911, Walker and Weeks left Dyer to create their own firm. Among the many public buildings they designed are Public Auditorium (1922), the Federal Reserve Bank (1923), Cleveland Public Library (1925), and Cleveland Municipal Stadium (1931).

GLAZER-MAROTTA

Working Partners
In 1960, Samuel Glazer (1923–2012) (left) and Vincent Marotta (right) check a map before starting out on field trips over their vast real estate empire. Their office building at 20515 Shaker Boulevard in Shaker Heights once housed the Van Sweringen Company, the chief developer of Shaker Heights and Beachwood on the East Side. As real estate developers, Glazer and Marotta built homes and shopping malls.

Howard Whipple Green
Howard Green (1893–1959) turned his fascination with numbers into a 30-year career as a statistician for Cleveland. Green moved to the city in 1923 to head the Bureau of Statistics & Research for Cuyahoga County. In 1930, when Cleveland's population topped 1.2 million, Green, who oversaw the census, used the data to track trends that might be used to better serve the health and welfare of residents and help businesses grow. The result was the creation of the Real Property Inventory in 1932, which, under Green's direction, provided basic statistics on everything in Cleveland for the purpose of continued growth and improvement.

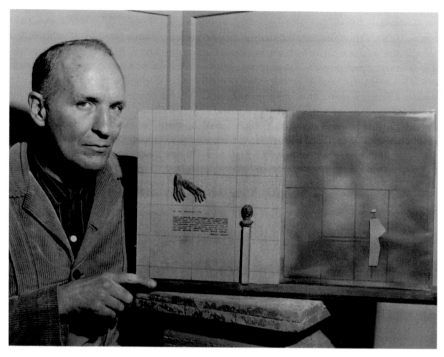

"Helping Hands"
In this 1959 photograph, famed Cleveland artist and sculptor William McVey displays his Memorial to Bell Greve, shown here in his studio at the Cleveland Institute of Art, to honor her for all her years of sacrifice and service to others in the Cleveland community.

Bell Greve
Belle Greve (1894–1957) was a social worker who, for 20 years, served as executive director of the Cleveland Rehabilitation Center where she introduced new relief and rehabilitation services to aid those in need. A Clevelander, Greve gained valuable experience in rehabilitative services while she worked at Hiram House. Beginning in 1918, she volunteered to provide charitable and hospitality services in the city. In 1933, she headed the newly-created rehab center on East 55th Street to meet the needs of disabled children and adults as they worked to attain self-sufficiency. From 1953 until her death, Greve continued her distinguished service to the city as head of the Department of Health and Welfare.

Almeda C. Adams

Almeda C. Adams (1865–1949) was a blind musician who helped fund the Cleveland Music School Settlement, which provided free individual instruction to students in all areas of music including voice, instruments, theory, and composition. Adams believed that—handicapped or not—anyone who desires to learn music should be afforded the opportunity to do so. Born in Pennsylvania, Adams lost her sight in infancy and was sent to the State School for the Blind in Ohio. She enrolled in the New England Conservatory of Music in Boston to pursue her love of music. She became a music teacher, specializing in voice and piano, and taught in settlement houses in Cleveland. With the help of Adella Prentiss Hughes, founder of the Cleveland Orchestra, Adams was able to secure the capital needed to start the Cleveland Music School Settlement in 1912. For Adams, music was life, and she continued to teach until 1948.

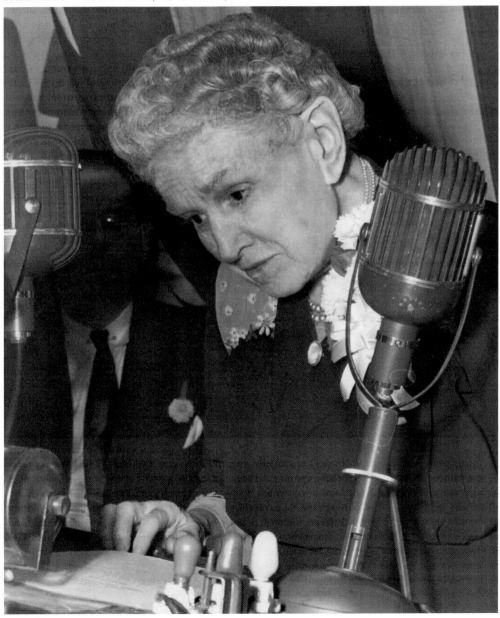

Harriet Louise Keeler
Harriet Keeler (1846–1921) devoted more than 40 years to the Cleveland Public Schools and its students. Keeler moved to Ohio from New York to attend Oberlin College, graduating in 1870. She came to Cleveland and worked as a teacher and principal at Central High School, her first assignment. An avid reader, Keeler continued studying and wrote textbooks and nature books. (Cleveland Public Library Photograph Collection.)

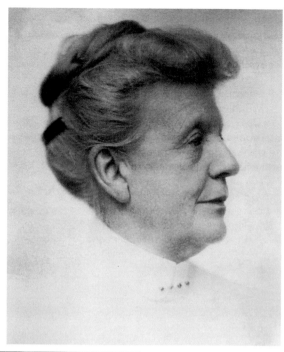

Harriet Louise Keeler Memorial
In the Brecksville Reservation of the Cleveland Metroparks is the Harriet L. Keeler Memorial Woods. This area was set aside in recognition of her more than 40 years of service in the Cleveland Public Schools. The simple stone monument and 300-acre location were chosen because of Keeler's lifelong interest in nature.

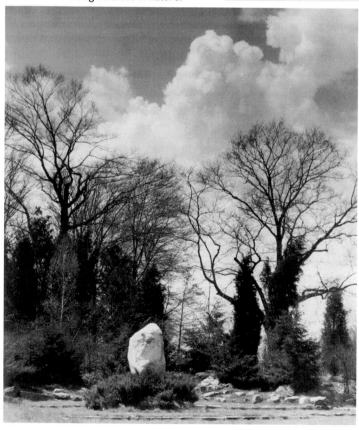

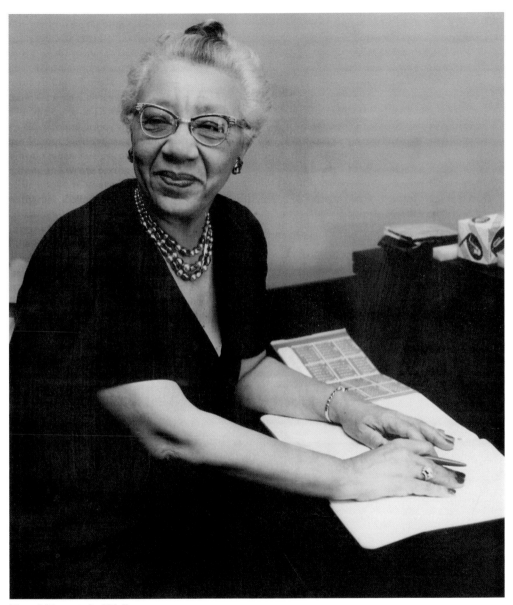

Hazel Mountain Walker

Hazel Walker (1889–1980) was a career educator who focused her many talents on helping struggling students in Cleveland public schools. Walker received her primary education in Warren, Ohio, then moved to Cleveland to pursue teaching credentials, which she received from the Cleveland Normal Training School, a teacher-training school, then Western Reserve University, where she earned her bachelor's and master's degrees in 1909. Her first Cleveland assignment was at Mayflower Elementary School in 1909. Her concentration was in teaching the children of immigrants how to read, as often the parents knew little or no English. In 1936, Walker was assigned to Rutherford B. Hayes Elementary School, where she became the first black principal of a Cleveland public school. Hazel Walker set a fine example for her students when she pursued her own studies in law, graduating with a degree from Baldwin-Wallace College and becoming one of the first black women lawyers in Ohio. She ultimately chose education over law, as her passion to help children never wavered.

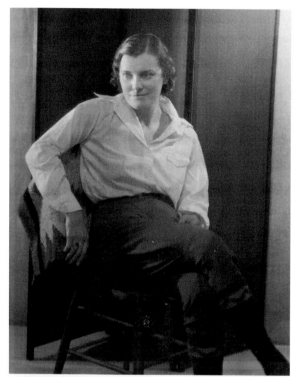

Bernice Goetz

Bernice Goetz (1909–1958) was an explorer who led expeditions to Central and South America, collecting artifacts and colorful stories of her exotic travels. A native Clevelander, Goetz worked as a secretary by day to finance her travels. As pictured here, Goetz preferred to lose the skirt and don menswear for her adventures. She made her first trip at the age of 22, to Mexico. Goetz was a popular public speaker and, when not drawing crowds to hear of her latest travels, she would write extensively, contributing to newspapers and even *National Geographic*.

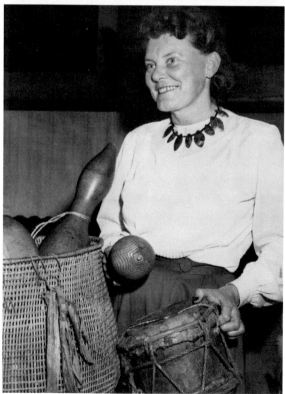

Bernice Goetz "Artifacts"

It was uncommon for a woman in the 1930s to have the kind of adventures Bernice Goetz organized for herself. She made 13 expeditions in all and was generous with her finds. She presented many artifacts, including those pictured here, from archaeological sites and from people she befriended along the way to the Cleveland Public Library and the Cleveland Museum of Natural History.

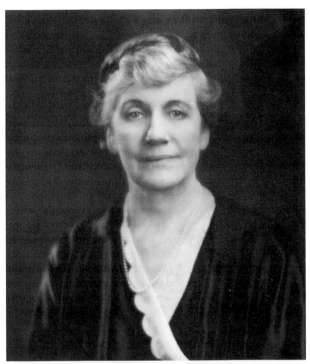

Linda A. Eastman

Linda Eastman (1867–1963) worked over 40 years for the Cleveland Public Library and had the distinction of being the first chief librarian of a major library when she took the helm of CPL in 1918. Eastman joined the library in 1892 as an assistant and became vice librarian in three years. As chief librarian, Eastman had 20 years (she retired in 1938) to expand the collection and oversee the opening of a new Cleveland Public library in 1925. She is pictured below with Dr. T.P. Stevensma, the chief librarian for the League of Nations, who visited Cleveland specifically to tour the new library. He was most impressed and called it the finest library to date of those he had visited. He had high praise for Eastman, who worked to expand services for the disabled and provide patrons with travel and other current information.

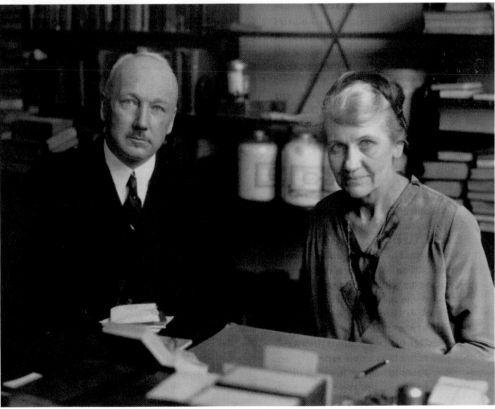

William A. Stinchcomb, Father of the Cleveland Metroparks

William Stinchcomb (1878–1959) was a city engineer when he helped found the Cleveland Metroparks system in 1913. The *Dictionary of Cleveland Biography* refers to him as the father of the park system, as he led the effort to persuade the Ohio legislature to authorize the legal establishment of parks on public property for recreational purposes. Stinchcomb, who began working in Cleveland in 1895, was chief engineer of the City Parks Department when legislation creating a metropolitan park system was passed. He was the obvious choice for director. He believed that parks and recreation created a natural bond that improved the life of the community. His legacy was a park system that draped around the Cleveland area like an "emerald necklace."

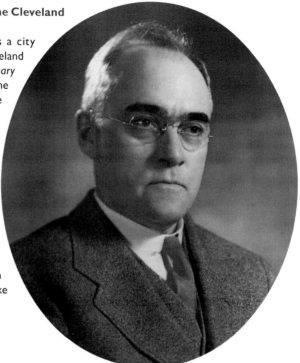

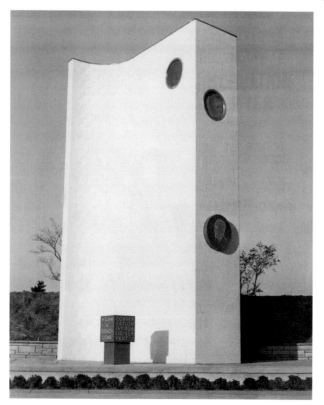

Stinchcomb-Groth Memorial
Stinchcomb was the director of the Cleveland Metropolitan Park district until he retired in 1957. Harold W. Groth succeeded him as park director. Groth was a civil engineer when he joined the park system in 1940. As director, he embarked on a five-year plan to acquire more land for the parks. The Stinchcomb-Groth Memorial, located in the Rocky River Reservation, was designed by Ernest Payer, architect; and William McVey, the sculptor who designed the 30-foot-high tower.

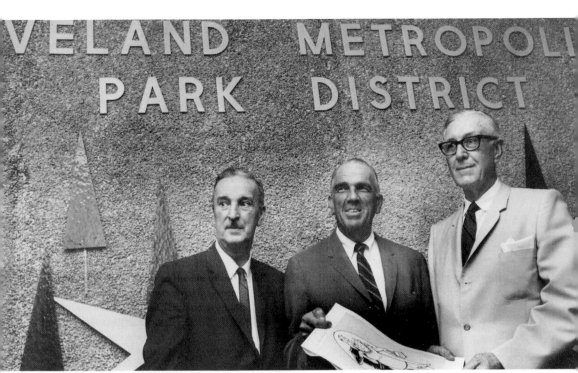

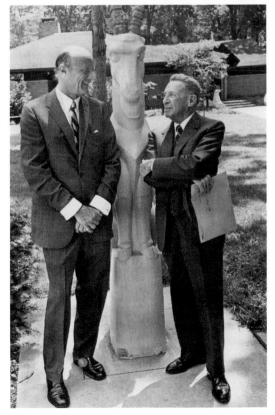

Harold W. Groth

Harold Groth (b. 1899) served as park director until 1974. Under his leadership, the Cleveland Metroparks system continued to expand to include 16,000 acres of land comprising 10 reservations surrounding the city, making it one of the finest parks in the world. When Groth took over as director, the park recorded over 12.5 million visitors in one year. Pictured with Groth (left) are Bill Roberts, the *Cleveland Press* editorial cartoonist; and Lee C. Hinslea (right), the park board president.

Courtney Burton

Courtney Burton (1912–1992) was a successful businessman and conservationist who actively participated on the boards of both the Cleveland Zoological Society and the Metropolitan Park System when the zoo joined the park district in 1970. In this photograph, Burton (left) and Frederick Crawford, another Zoological Society member, pose with a goat statue that once stood sentry at the end of the Leisy Brewery driveway and was donated when the brewery was razed.

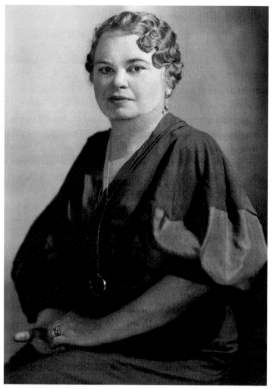

Helen Horvath

Helen Horvath (1872–1943) came to Cleveland from Hungary in 1897 and worked to help fellow immigrants become immersed in American society without sacrificing their European heritage. It was a delicate balancing act but one Horvath felt necessary to succeed. She focused on language skills and, in 1901, opened the first of several schools to teach immigrants English as well as American customs. Her success led to lectures and tours.

Ernest J. Bohn

Ernest Bohn (1901–1975) was a founder and director of the first public housing project in the United States, the Cleveland Metropolitan Housing Authority, from its inception in 1933 until his retirement in 1968. The Hungarian-born Bohn moved to Cleveland with his family in 1911. He became a lawyer and turned his attention towards clean, affordable housing for everyone. His efforts led to the first US Housing Act, passed in 1937. Pictured here is Bohn (center) with members of "Operation Demonstrate."

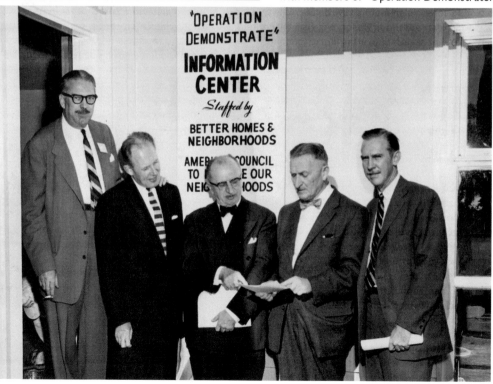

George A. Bellamy

George Bellamy (1872–1960) was a civic activist and social reformer who founded one of the first settlement houses in Cleveland, Hiram House. Bellamy moved from Missouri to Ohio to begin ministry studies at Hiram College in 1892. It was during his days at Hiram that he switched his interests to social work and settlement houses, which gained in popularity as a reform movement during the 1890s. The idea of building settlement houses in large cities grew out of the problem of overcrowding and impoverished conditions arising from industrialization and overpopulation. Bellamy and several college students opened Hiram House in 1896. He took over as director in 1897 and remained in control until 1946. Under Bellamy's lead, Hiram House found a permanent home on Orange Avenue on Cleveland's east side. Bellamy was able to finance the operation of Hiram House through the generous donations of many of Cleveland's most prominent leaders and families. He worked tirelessly to promote Hiram House programs, especially those for children. In 1900, he established the first evening playground at Hiram House and pushed for a recreational bond issue in 1912 to open city-wide playgrounds, of which he became the supervisor.

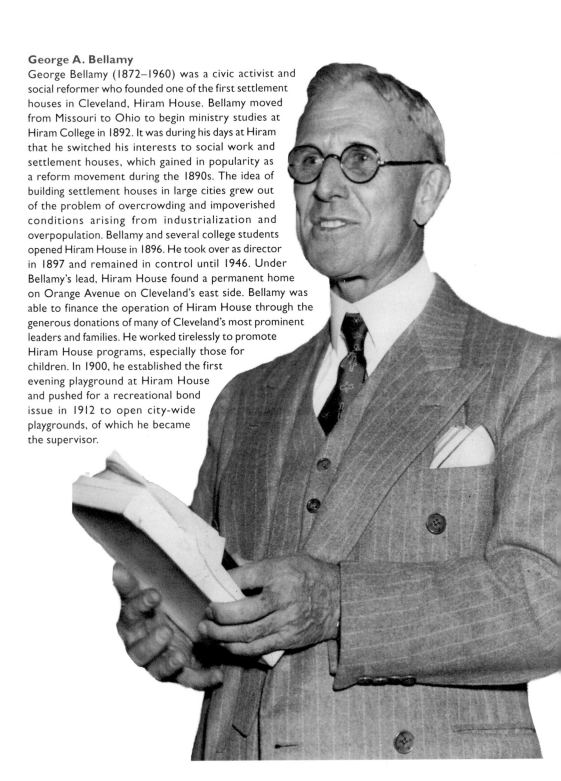

Helen Millikin Nash

Helen Nash (1893–1990) was a socialite and conservationist who was instrumental in the establishment of the Shaker Lakes Regional Nature Center in 1966. It was Nash who saved the area from being converted into a freeway with an anonymous donation for a study giving the Shaker Lakes area landmark preservation status. A Clevelander, Nash was president of the Shaker Lakes Garden Club and later took control of the Garden Center of Greater Cleveland, where she steered the club into community activities.

Roberta Holden Bole

Roberta Bole (1876–1950) was a socialite, philanthropist, and civic activist who moved to Cleveland with her family from Utah in 1891; later, she used her resources and influential connections to improve education and culture in the city. She helped found a home for the Cleveland School of Art, organized a fundraiser to preserve the historic Dunham Tavern on Euclid Avenue, and helped establish classes for gifted children in Cleveland Public Schools. She helped found Holden Arboretum, a nature preserve in Kirtland, Ohio. Bole was also a trustee and benefactor of the Cleveland Museum of Art and the Cleveland Museum of Natural History.

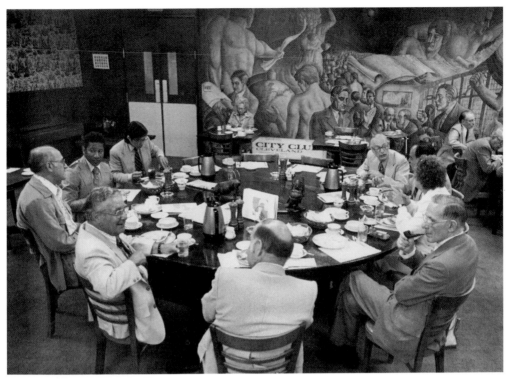

The City Club

Originating in the Citizens Building on Euclid Avenue, the City Club was a meeting place for people of varied backgrounds and interests to get together and speak freely and openly about the state of the city and other affairs of the day, be they social, political, economic, or philanthropic. Guest speakers were invited to entertain on any number of topics.

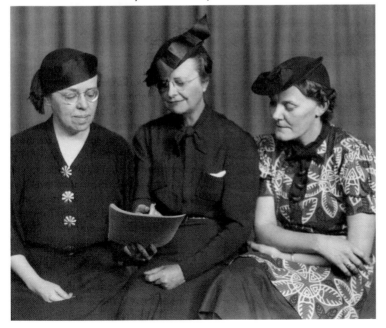

The Women's Advertising Club

This club was organized in 1919 in order to promote a greater role for women in the business world, particularly in the field of advertising. Pictured in 1937 from left to right are Gladys Stevens, Katherine Gibbons, and Bernice Goetz. The club attracted women like Goetz who wanted more from life than the traditional roles offered women.

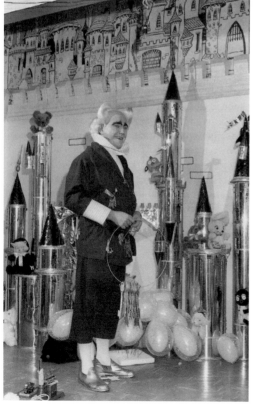

Samuel Halle and the "Keeper of the Keys"
Samuel Portland Halle (1866–1949) founded Halle Department Store with his brother Samuel Horatio Halle. Seen here at left, he contributed heavily to philanthropic activities. Mr. Jingeling, "Keeper of the Keys," was a fictional character and staple of Cleveland's Christmas holiday traditions. He is best remembered as portrayed by Earl Keyes, a local producer/director of children's programming. When Halle's Department Store on Euclid Avenue wanted to promote its toy department on the seventh floor in 1956, a Chicago advertising agency created the concept of Mr. Jingeling, who saved Christmas one year when Santa lost his keys. Mr. Jingeling made a new set and was appointed keeper of the keys by Santa. The character became instantly popular and was kept as a Halle fixture for years. He was featured on the *Captain Penny Show*, and would excite children about the holiday season through songs and storytelling. When Halle's closed in 1982, Mr. Jingeling moved his shiny castle to Higbee's Department Store on Public Square, where he remained for over a decade. Earl Keyes last portrayed him in 1995.

CHAPTER TWO

Legal, Political, and Criminal Legends

The legal, political, and criminal legends in Cleveland's history are comprised of individuals who either sought to make a positive contribution to their community or simply aimed to profit only themselves. Women had always been active in securing voting rights as the work of suffragettes like Lillian Westropp and Lucia McBride in getting votes for women attests. And then individuals like Harry Bernstein wanted to make sure the right votes were cast. With two law schools in town, Cleveland-Marshall College of Law and Case Western Reserve University Law School, Cleveland has produced many lawyers and jurists who legislated and worked to improve existing laws. Florence Allen, Mary Grossman, and Perry Jackson proved themselves to be good jurists. And if the law needed to be changed, activists like the Rev. Bruce Klunder, Lillian Andrews, and Chief Thunderwater strove to get their message across. There was heartbreak, as when young Beverly Potts disappeared one evening from a summer fair, leaving investigators like Dr. Samuel Gerber to try and piece together a story of what happened to her or to the countless others who disappeared or were murdered. Some of Cleveland's criminals were colorful characters, like Cassie Chadwick, who tried to swindle her way to fame and fortune; or Danny Greene, a racketeering kingpin who met a violent end. All together, the individuals herein chronicle the developing history of Cleveland's legal and political landscape and sometimes provided enough drama to attract filmmakers.

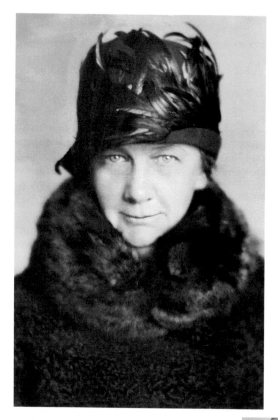

Lucia McCurdy McBride, "Votes for Women"

Lucia McBride (1880–1970) was a wealthy socialite and noted activist involved in many organizations integral to the city of Cleveland, especially those impacting the day-to-day lives of women. Most prominently, McBride participated in the women's suffrage movement by rallying support for the League of Women Voters of Cleveland. Similarly, McBride was a founder of the first birth control clinic in Cleveland, one that later became the Cleveland branch of Planned Parenthood. Her activism did not stop there. She served as the vice-chair for the Ohio Council for National Defense in support of US involvement in World War I, and later advocated for peace. Also active in supporting labor and wage regulations, she spoke out against child labor and was in favor of minimum wages for women, which in 1923 had not yet been made a federal regulation. Her service to the community and wide interest in the betterment of the city also included work with the Cleveland Institute of Art, the Cleveland Playhouse, and the Cleveland Museum of Art.

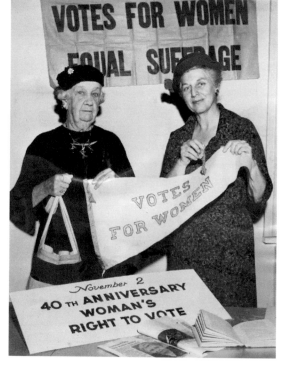

Celebrate the Vote
Lucia McBride (left) holds a banner with Mrs. Donald F. Stroup, president of the Women's City Club, as they celebrate women's right to vote.

Harry Bernstein, the Republican "Czar"

Harry Bernstein (1856–1920) was a prominent political boss for the Republican Party who bore the catchy nickname "Czar" for his success in delivering votes to whichever candidate he supported. He was also a Cleveland councilman who advocated for immigrants and helped them assimilate into society. Bernstein founded the People's and Perry's Theaters to showcase local talent. As a small businessman, restauranteur, and banker, Bernstein made it a priority to employ immigrants.

Votes for Women

Lillian Westropp (center) is joined by Nancy O'Laughlin (left) and Margaret Dreier as they campaign to get the vote for women. Westropp long championed the rights of women, not just for voting but in all aspects of life. Her time on the bench allowed her to serve as an inspiration to women seeking more than traditional roles to fulfill.

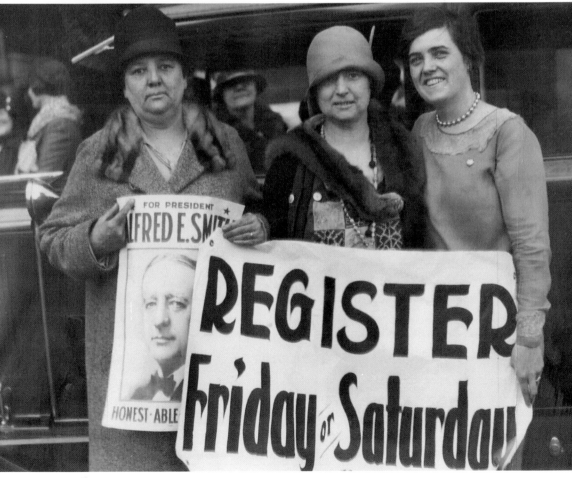

Judge Florence E. Allen

Florence Allen (1884–1966) was a trailblazer as she strove to occupy positions previously unattainable by even the most highly educated women. As a suffragette, Allen pursued a legal career when her music career abruptly ended. She supported herself as a teacher and newspaper columnist as she sought admission to Western Reserve University School of Law. Women students were not welcome. Undaunted, Allen studied law in New York and Chicago and passed the Ohio bar in 1914. Women lawyers were scarce in her day and female assistant county prosecutors, Allen's first legal position, were even rarer. She performed her duties well and chose to pursue a legal career on the bench instead of before it. In 1920, she won elections to the Court of Common Pleas, followed by a seat on the Ohio Supreme Court in 1922, and an appointment to the 4th Circuit Court of Appeals by Pres. Franklin Roosevelt. She continued her career as a jurist and retired from the bench in 1959.

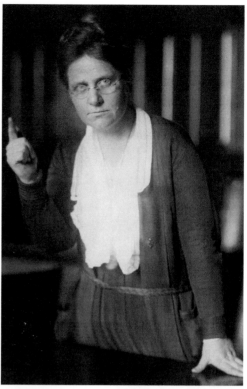

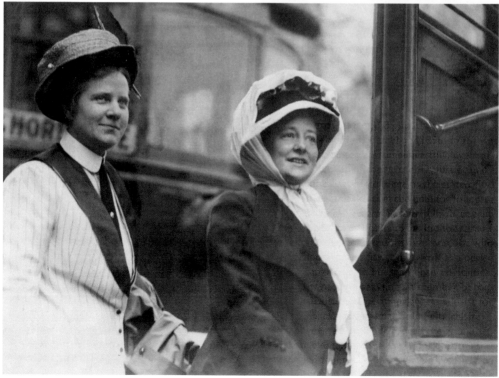

Judge Mary B. Grossman

Mary Grossman (1879–1977), a native Clevelander, was the first female municipal judge in the United States. After receiving her law degree from Baldwin-Wallace College in 1912, Grossman (center) passed the Ohio bar and became the third female lawyer from Cleveland and one of the first admitted to the Ohio Bar Association. Like those who followed her, Grossman was active in women's suffrage and at one point served as the chair for the League of Women voters. She was also a board member for the Alta House settlement house. She was known as fair and sympathetic and was active in the judicial system until she retired in 1959.

Judge Perry B. Jackson

When Perry Jackson (1896–1996) was appointed to the bench of Cleveland Municipal Court in 1942, he became the first black judge in the state of Ohio. Jackson received his law degree from Western Reserve University Law School in 1922 and passed the Ohio bar. He opened his own practice while he worked for seven years as a police prosecutor. He then entered politics, where he served as a member of the Ohio general assembly. As a jurist for Cleveland Municipal Court, Jackson served until 1960, when he won election to the Domestic Relations Division of Common Pleas Court. He retired in 1973.

Albina Cermak

Albina Cermak (1904–1978) will always be remembered as the first woman to run for mayor of Cleveland. Her opponent in 1961 was Anthony Celebrezze, who handily won, but Cermak ran her own race and proved women were just as adept at politics as men. Cermak was a staunch Republican who represented her party as a delegate to the Republican National Convention and chaired the Republican Women's Organization in Cuyahoga County. Her party loyalty secured her a position as a bailiff in 1964, the first woman to hold the job in Common Pleas Court.

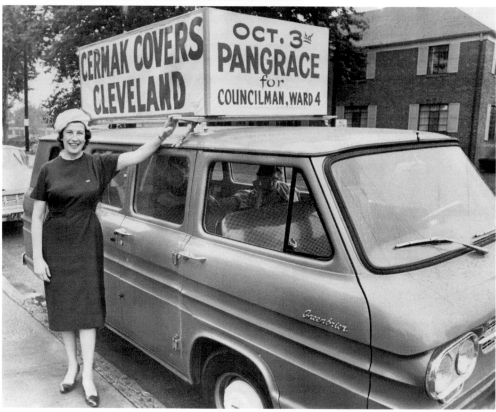

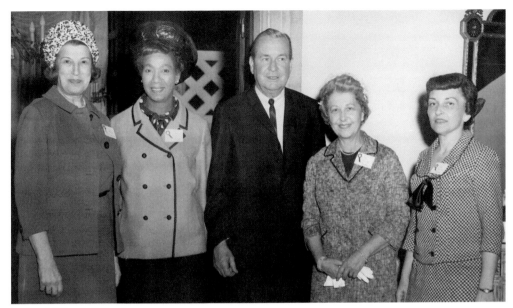

Judge Lillian W. Burke

In 1969, Lillian Burke (1918–2012) was named the first black female judge in Ohio by Gov. James A. Rhodes. Burke (second from left) had been a member of the Ohio Industrial Commission when tapped by Rhodes. She remained on the bench of Cleveland Municipal Court until her retirement in 1987. Burke is seen here in 1966 with fellow Republicans Albina Cermak (far left), Governor Rhodes, Lucille Cooks, and Jeanne Brodie (far right), all newly-appointed to Governor Rhodes's Committee on the Status of Women from Greater Cleveland.

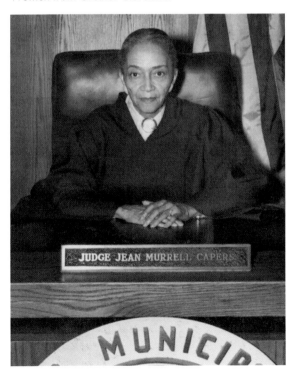

Judge Jean Murrell Capers

Now retired, Jean Murrell Capers (b.1913) was a practicing attorney when, in 1949, she became the first black councilwoman of a major American city, an elected position she held for four full terms. As a politician, Judge Capers fought for minority rights in the areas of employment, housing, and recreation. Upon leaving city council in 1959, Judge Capers took a position as an assistant attorney general for Ohio. In 1977, she ran a successful campaign for a seat on Cleveland Municipal Court where she remained until her retirement as a jurist in 1986. Judge Capers then returned to private practice, specializing in elder law, until her retirement at the age of 99.

Rev. Bruce W. Klunder
Rarely in Cleveland's history has an issue stirred such intense debate and emotion as the desegregation of public schools. Two possible solutions were presented: bus students crosstown to integrate all schools or simply build more schools. Reverend Bruce Klunder (1937–1964) believed the latter solution would not solve the problem. In April 1964, the minister and civil rights activist was one of four demonstrators protesting at the construction site of a new school. Reverend Klunder decided to throw himself in front of a bulldozer in operation in an attempt to stop all work. Tragedy struck when the operator failed to see Reverend Klunder lying face-down on the ground and ran the machinery over him, killing the reverend instantly. The operator was cleared of any wrong-doing. Reverend Klunder became a martyr and over 150 people marched in silence before the Board of Education in remembrance.

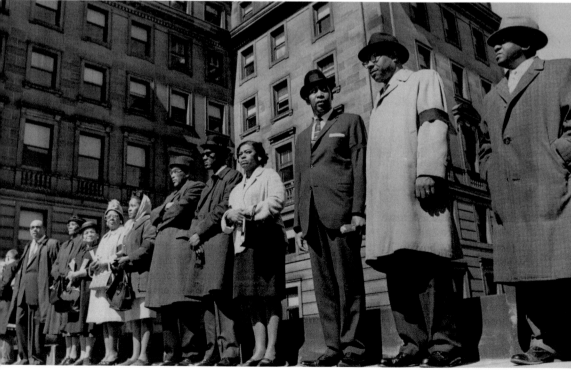

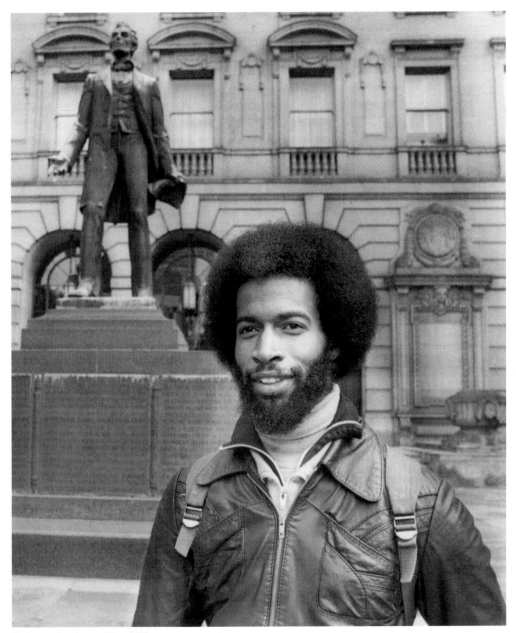

Robert Anthony Reed III
Robert Reed was the plaintiff in a major desegregation case decided in Cleveland. When federal judge Frank Battisti gave the order for desegregation of Cleveland public schools, there were those who believed building better schools and employing better teachers would be more effective than busing children crosstown. In the case of *Reed v. Rhodes* presented in the US District Court for the Northern District of Ohio, Reed argued that the State of Ohio and the Cleveland Public Schools intentionally created and maintained a racially segregated school system that violated the 14th Amendment rights of black schoolchildren. Judge Battisti agreed in 1976, and busing was born. Reed is standing before the Board of Education building where the statue of Abraham Lincoln, created by Cleveland sculptor Max Kalish, stands.

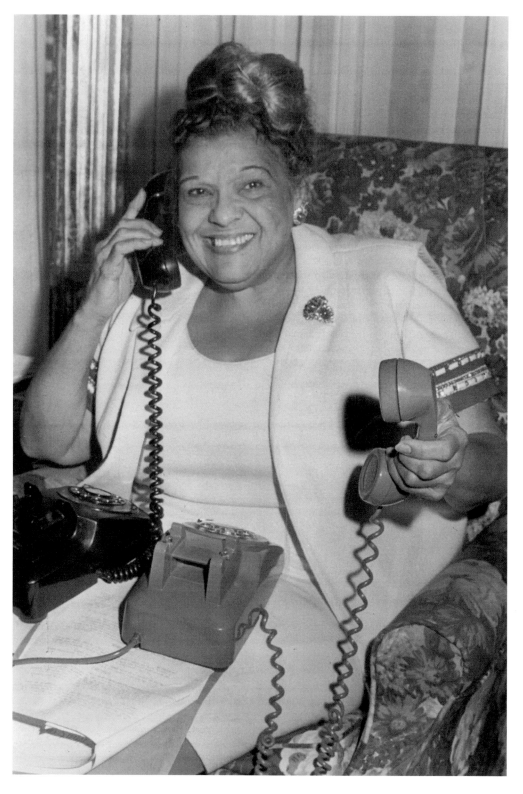

Zelma Watson George (OPPOSITE)
Zelma Watson George (1903–1994)
was a multi-faceted and multi-talented
woman who was an accomplished
singer, writer, and actress involved
in social causes at home and abroad.
After graduating from the University
of Chicago she studied music and
then moved to Cleveland, where she
focused on her dramatic talents. She
wrote dramas and musicals, one of
which played off-Broadway. George
appeared in numerous productions at
Karamu House and taught at Cuyahoga
Community College. She was the
director of Cleveland Job Corps and
served as a goodwill ambassador to the
United Nations.

Chief Thunderwater
Chief Thunderwater (1865?–1950),
who also went by the name Oghema
Niagara, was the titular head of the
Supreme Council of Indian Tribes of
the United States and Canada and a
descendant of a long line of warrior
chiefs. He was an activist who fought
long and hard for Native American
rights and to keep the Erie Street
Cemetery, which holds the grave of
Joc-O-Sot, from being condemned. He
succeeded, and his cremated remains
rest at Erie Street Cemetery.

Marion Winton Strongheart Campbell
Socialite Marion Campbell (1897–1944)
was known as a prominent and vocal
activist for Native American rights,
especially in the Cleveland area. It
was her study of Native American
history and mistreatment by the
federal government that led Campbell
to set aside her own needs to help
meet theirs. In 1929, she founded the
Women's National League for Justice
to American Indians. She was also an
opera composer who had her work
featured by the Cleveland Opera
Company. She was once married to
Alexander Winton.

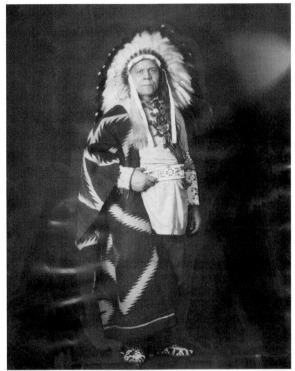

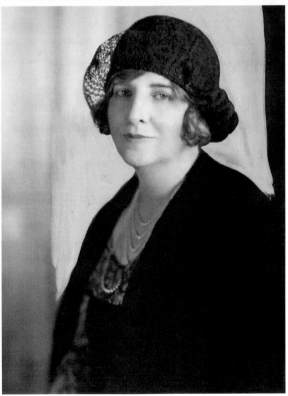

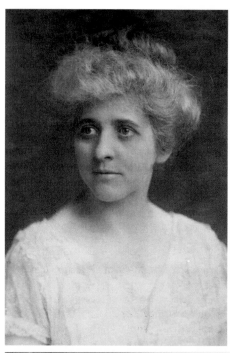

Bernice Pyke

Bernice Pyke (1880–1964) taught mathematics in Illinois after receiving her advanced degrees in Ohio before she returned to Cleveland and became active in the Women's Suffrage Movement. She was active in promoting the candidacy of a few politicians and was the first female delegate to a national political convention. Later in her career, she was appointed to Mayor Raymond Miller's cabinet as the director of public welfare. In 1934, President Roosevelt made her the collector of customs in the Cleveland area, a position she held just shy of 20 years.

Mercedes Cotner

Mercedes Cotner (1905–1998) was a councilwoman and longtime clerk of courts in Cleveland. In 1963, she became the first woman clerk, a position she held for over 25 years. Cotner was also the first woman Democratic mayoral candidate for Cleveland. Her passion for politics and her influence were legendary and many sought her out as an ally. She is pictured here with James Stanton (left) and Mayor Ralph Locher (right)

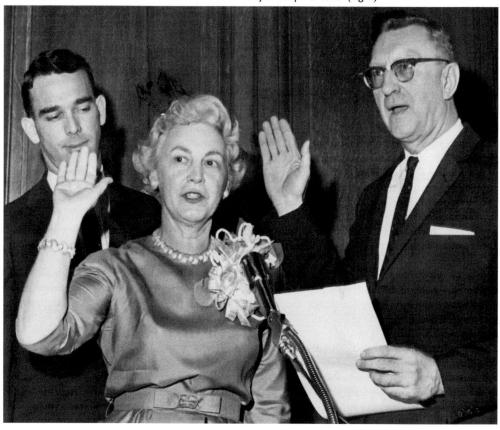

Gen. Benjamin O. Davis

Benjamin Davis (1912–2002) was the first black general in the US Air Force and was commander of the legendary World War II Tuskegee Airmen. Born in Washington, DC, Davis became the highest-ranking African American in military history at the age of 58. He was president of his class at Cleveland Central High School and, in 1936, became the first African American to graduate from West Point in decades. In 1970, he served briefly as Cleveland's safety director under the administration of Mayor Carl B. Stokes. Davis is pictured below taking the oath, with Mayor Stokes. After he left Cleveland, Davis accepted an appointment by President Nixon to head the US Civil Aviation Security Office, which was charged with putting an end to hijackings. He supported the use of metal-detecting devices and hijacker profiling to deter potential threats. A small airfield in downtown Cleveland was named in honor of General Davis.

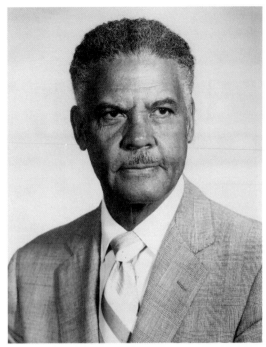

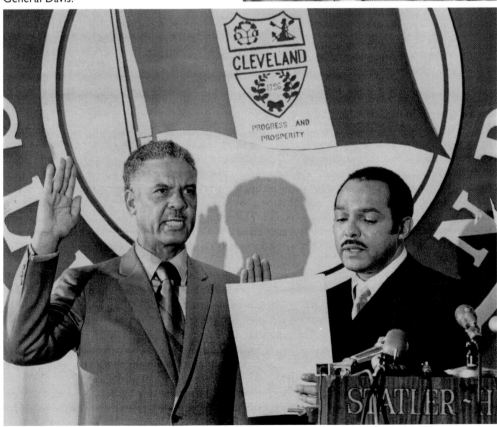

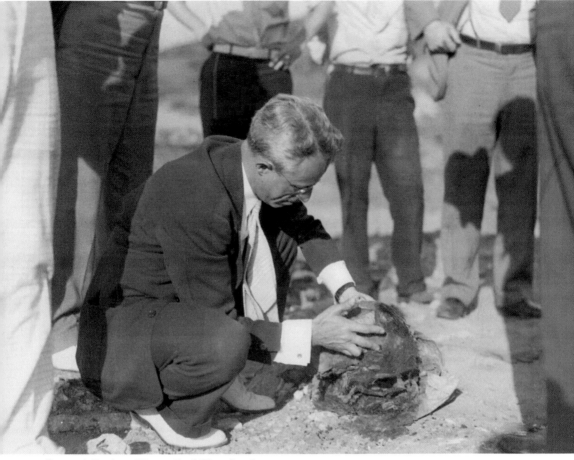

Samuel Gerber "Bones" of Cleveland

Samuel Gerber (1898–1987) made his entrance to the Cleveland Community as a member of the Department of Health and Welfare, serving as a physician. After obtaining his law degree, Gerber was then able to practice in front of federal courts. However, he is best known for his innovations in the Cuyahoga County Coroner's office, where he worked on high-profile cases like the Torso and Sheppard murders. In this photograph, Dr. Gerber is examining what appears to be a skull, possibly related to the infamous Torso murder cases. Dr. Gerber authored *The Encyclopedia of Death*, which chronicles the most interesting cases to come his way and how the exact cause of death could be determined even when more than one method was used to cause a person's demise.

Beverly Potts (OPPOSITE)

The disappearance of Beverly Potts remains one of the most haunting and heartbreaking mysteries in Cleveland history. At age 10, Potts was last seen on August 24, 1951, at Halloran Park on Cleveland's West Side, less than a mile from her home. Beverly had gone that evening to a summer festival that drew large crowds—close to 1,500 people. It was past 8:30, and her girlfriend had gone home, but Beverly stayed as she had permission to do so until the program had ended at 9:30. When she did not arrive home by 10:30, her parents called the police, who then launched an intensive search. Beverly had disappeared, and the stories surrounding this tragedy were only beginning. Many theories have been advanced over the years about what may have happened to her. Some have even claimed involvement, perhaps for the sake of notoriety. This is certain: Beverly Potts vanished that August night, and not a single clue remained as to her whereabouts.

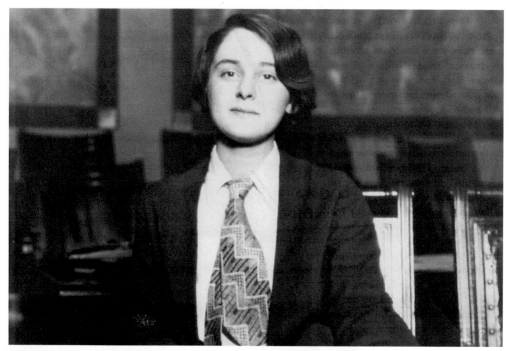

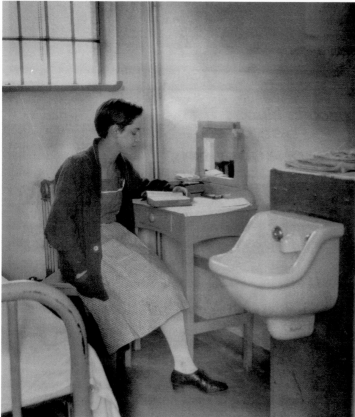

Lillian "Lil" Andrews
Lillian Andrews was a young Communist agitator of the 1930s who had the ability and leadership skills to rally thousands to march on city hall to demand jobs. Her rallying cry was "All I've got to say is that we're going to fight for work or wages." As the district organizer of the Young Communists League, she did not have the appearance of someone bent on radical unrest. Andrews would stand atop the bronze statue of Mayor Tom L. Johnson on Public Square as she addressed the crowds. Sometimes they would march in protest to city hall; other times, police intervention might lead to arrests and a 30-day stay in the workhouse.

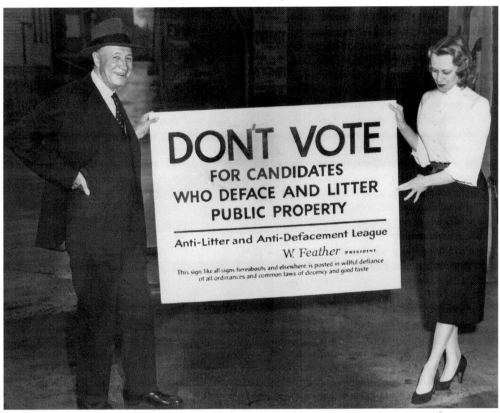

William Feather Will Knock You Over

William Feather (1889–1981) was a journalist known for his eponymous magazine, the *William Feather Magazine*, which he created in 1916, and his column for the *Cleveland Press*. He was a member of the City Club and the Union Club, where he liked to go to argue with the radicals. He was also an accomplished author who published several books through his printing business, The William Feather Co.

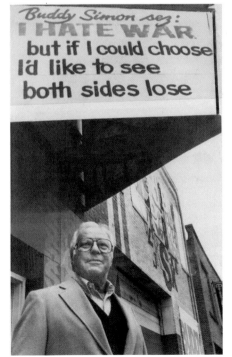

Buddy Simon Sez

Buddy Simon was a legend among Clevelanders who might live or travel in and about Carnegie Avenue. For over 30 years, Buddy Simon's signs would hang high. He used the billboards to comment on whatever topic might be pertinent for the day. In 1981, he authored his only book, *Simon Sez*, highlighting the best of what he had to say since 1959.

Alex Shondor Birns

Shondor Birns (1905–1975) was a career criminal who accumulated a laundry list of charges throughout his life, from theft to prostitution and numbers and, finally, murder. Not the subtlest of criminals, he appreciated the attention of newspapers that labeled him as a notorious threat. Despite numerous arrests, his connections within the judicial system allowed him practically a free pass from long stints in jail. Even when the government attempted to deport him to Hungary, he was unwelcome in any country and thus remained in the United States until his death. Birns met the same fate as Danny Greene, blown to bits by a car bomb; just like Greene, no suspects were ever found.

Jackie Presser

Jack Presser (1926–1988) was a well-known leader of the Teamsters Union in the days of Jimmy Hoffa, and a labor advisor to President Reagan. Attending Cleveland schools, his first successful job was from his father, who made him the secretary treasurer of Local 507. Presser held more union positions and then was elected as international vice president of communications in 1976. Even though he and his father, William Presser, were informants for the FBI, this notoriety did not stop Jackie from being elected the president of the International Union before his work for Reagan.

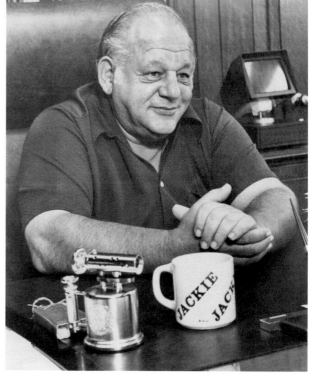

Daniel "Danny" Greene

Daniel Greene (1929–1977) was one of Cleveland's more infamous criminals, suspected of racketeering and later a car bombing and murder. A high school dropout, Greene was initially the president of Local 1317 of the International Longshoremen's Association, but it was not long before he was accused of taking money for labor assignments and later for embezzlement. Due to a legal technicality the conviction did not hold, but Greene was still unable to keep out of trouble and lost his union position after more violations of union laws. More high profile was his war with a rival, Michael Frato, who was the target of the car bombing in 1971. Greene shot him in "self-defense" after the failed bombing and later took over racketeering after Shondor Birns was jailed yet again. Greene met his end in a 1977 car bombing in Lyndhurst after surviving three other attempts on his life.

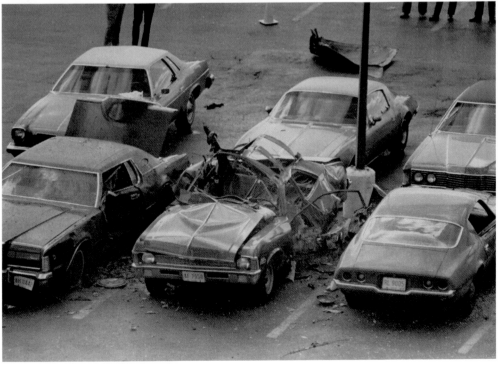

Cassie L. Chadwick, the Most Notorious Woman of Her Day

Cassie Chadwick (1857–1907) had the distinction of being Cleveland's most famous con artist. She was born Elizabeth Bigley and came from Ontario, Canada. Her first arrest came in Canada at the age of 22 on charges of forgery. She escaped punishment by pleading insanity. In 1882, she came to Cleveland and married a doctor, but her past brought about a quick end to the marriage. She became a fortune-teller in 1887, and in 1889 she was sentenced to prison for forgery. No insanity plea could save her. William McKinley, who was Ohio's governor at the time, did parole her after four years, and she returned to Cleveland. She married a second time and used her husband's name. As Cassie Chadwick, she focused on swindling banks by passing herself off as the illegitimate offspring of Andrew Carnegie in an attempt to seize monies using the Carnegie name. She succeeded in netting over $1 million but was arrested and sat through a very public trial in Cleveland in 1895. She was sentenced to 14 years in prison, where she died after one year.

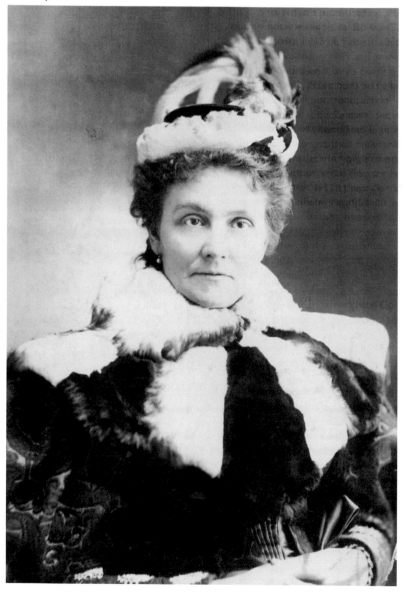

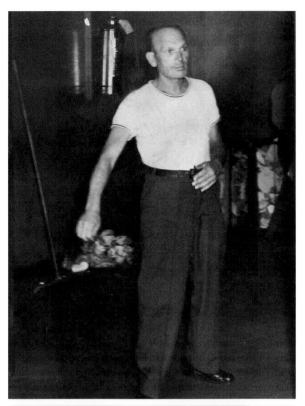

Louis Finkelstein, a True Prince among Thieves

Louis Finkelstein (1894–1964) better known by his professional moniker, "Louie the Dip," achieved notoriety as the "Prince of Pickpockets" following a 50-year career marked by the most arrests of anyone in the sleight-of-hand trade. The more than 120 arrests and numerous incarcerations kept Finkelstein from claiming speed and misdirection as strong skills, but it did earn him a place among Cleveland's notable criminals. Born in Odessa, Russia, in 1894, Finkelstein came to Cleveland in 1909 and immediately went to work on a lady's purse on Euclid Avenue. From here on Finkelstein lived a life of crime, arrest, sentencing, incarceration, release, and return to crime that continued until 1954 when, ironically, arthritis ended his career. It is said that crime does not pay and never was it more true than for Finkelstein, who lived his last years on welfare and died penniless in 1964.

Josiah Kirby, "White Collar Crime"

There are many ways to pick a person's pocket. Louie the Dip used the direct "hands-on" approach, while thieves like Josiah Kirby (1883–1964) use shadowy companies and third parties. Kirby was spurred by his own business failure to start the Cleveland Discount Company. This mortgage company was bought out by a larger organization that later filed for bankruptcy. From there, Kirby took his talent to the Cleveland Yacht Club, which met a similar fate as his two previous attempts and fell into bankruptcy. Convicted on several accounts of fraud and market rigging, Kirby was not deterred and was finally charged by the SEC with continuing to trade on the stock market.

Andrew Squire
Andrew Squire (1850–1934) was a close friend and advisor to many prominent Clevelanders and businessmen, including Samuel Mather and Cyrus Eaton (left). In conjunction with this, Squire (right) was a guide to other young lawyers after his own successful career in law as a partner in Squire, Sanders & Dempsey. Additionally, he acted as a trustee for Cleveland Quarries and Cleveland Union Stockyards.

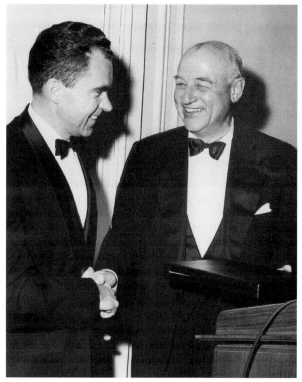

George Humphrey
George Humphrey (1890–1970) was hired by the M.A. Hanna Company in Cleveland as general counsel. He worked his way up to partner and would lead the Hanna Company as president. Humphrey had managed iron ore and other properties for the company. After his promotion to vice president of the company in 1922, he saved it from a staggering $2 million deficit. Humphrey was appointed by President Eisenhower as the secretary of the treasury before he retired back in Cleveland. He is seen here on the right with then senator Richard Nixon.

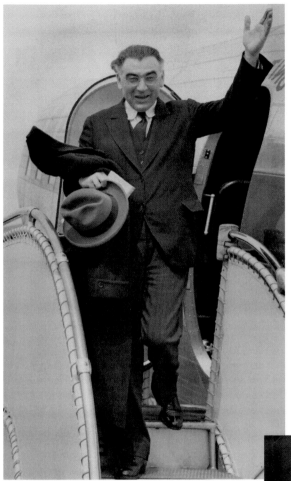

Rabbi Abba Hilel Silver

In 1917, Rabbi Abba Hilel Silver (1893–1963) came to Cleveland to become rabbi of Temple-Tifereth Israel, which he built into the largest Reform congregation in the United States. A rabbinic scholar, in 1924 he became the first president of the city's Bureau of Jewish Education. In 1933, Rabbi Silver helped found the League of Human Rights and was president of the Zionist Organization of America in 1945, working for the creation of the state of Israel. His activism continued as an advocate for unemployed workers and for the unionization of workers. His efforts led to the state's first unemployment insurance law while he sat on the Ohio Commission on Unemployment Insurance in 1936.

Newton D. Baker

Newton Baker (1871–1937) was a prominent Cleveland lawyer and politician. In 1899, he began practicing law in Cleveland and worked in the administration of Mayor Tom L. Johnson. In 1912, Baker was elected to the first of two consecutive terms as Cleveland's mayor. He also helped draft a state constitutional amendment giving cities the right of self-rule. Baker was a founding partner in the law firm of Baker, Hostetler and Sidlo. He was tapped by Pres. Woodrow Wilson to serve as secretary of war during World War I. Baker received many awards for his services and accomplishments.

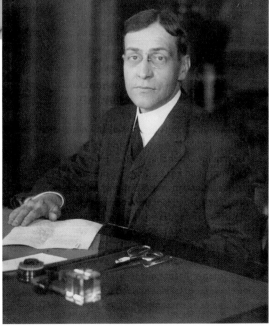

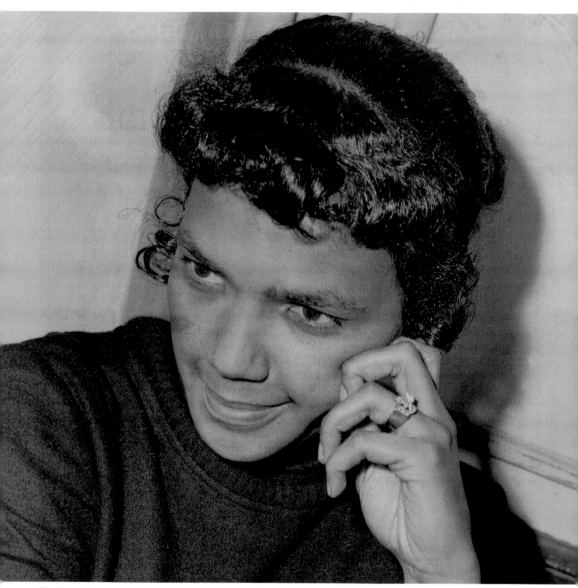

Dollree Mapp

In 1961, the US Supreme Court, Chief Justice Earl Warren presiding, rendered a landmark decision in the case of *Mapp v. Ohio* that said, simply, that evidence obtained illegally cannot be used in criminal trials as it violates the unreasonable search and seizure clause of the Fourth Amendment to the Constitution. Dollree Mapp's lone moment of celebrity was having been the wife of boxing champion Jimmy Bevins. When several Cleveland police officers came to her home on a tip that a suspect wanted in several bombings might be hiding out there, they requested to enter the home for a search, but Mapp refused. The officers left and returned a short time later with a piece of paper they claimed was a warrant to search. Mapp took the paper, a struggle ensued, and the officers arrested her when they found obscene materials in her home. In Ohio, possession of obscene material was illegal, and Mapp was tried and convicted. On appeal to the Supreme Court, the justices overturned her conviction as the lack of a proper search warrant left any evidence seized illegal. The implications of this case were far-reaching, as a valid search warrant must be presented before conducting any search or seizing any evidence for use at trial.

CHAPTER THREE

Scientists, Physicians, and Inventors

Cleveland has several world-class hospitals: the Cleveland Clinic, University Hospitals, and Case Western Reserve University and Medical School; therefore, it is no surprise that many great ideas for improving health care and inventions came from the Cleveland area. Pioneering heart surgeons like Claude Beck put Cleveland on the map for the finest cardiac care not only in America but the world. Mrs. Chew and Mr. Gasket helped improve automobile performance and provide cleaner air. And how about that cup of morning coffee? Vince Marotta, who invented Mr. Coffee, made it possible for us to wake up to a fresh brew every morning. Cleveland was also a city of firsts: the first female physician, the first kidney dialysis machine, innovations in autosynthetic cells, prosthetics for wounded veterans and others who desired a new limb, and the discovery by Dr. Charles Rammelkamp that the strep virus leads to rheumatic fever. And let us not forget the nurses. They served in both world wars and, because of the dedication of Frances Payne Bolton, nursing evolved into a profession requiring medical training and a college degree. Cleveland emerged a premier health provider and innovator due to the ingenuity and perseverance of these talented individuals.

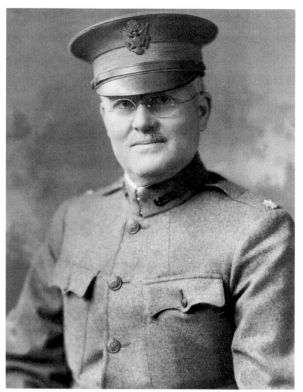

Dr. George W. Crile

Dr. Crile (1864–1943) was one of a group of physicians who founded the world-renowned Cleveland Clinic. He was chief of surgery at Lakeside Hospital and served in the US Army Medical Corps during both the Spanish-American War and World War I. Returning to Cleveland, Crile founded the Cleveland Clinic Foundation along with Dr. William Lower, Dr. Frank Bunts, and Dr. John Phillips. Crile served as president and trustee from 1921 to 1940.

Dr. Crile in Philadelphia

Dr. George Crile (second from left) explains the functions and construction of his cells during a 1931 lecture at Philadelphia's Jefferson Hospital. Dr. Crile is joined by his research team. Pictured from left to right are Dr. Chevalier Jackson, Dr. Crile, Dr. Maria Telkes, and Amy Rowland.

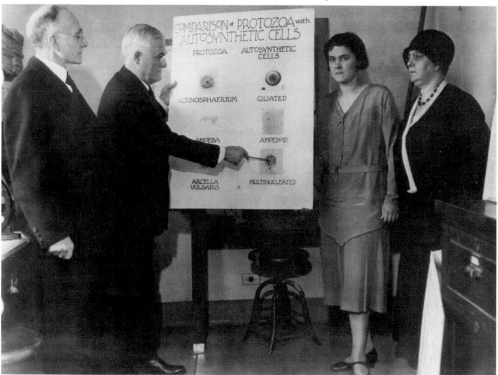

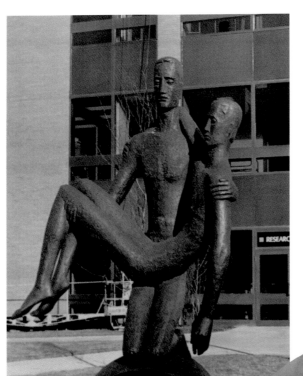

William McVey

Cleveland sculptor William McVey was commissioned by the Cleveland Clinic Foundation to create a piece that would convey the mission statement of the hospital to the community. McVey decided upon the image of one man carrying another in a powerful gesture of humanity. "Man Helping Man" was placed outside the research building and dedicated in 1976.

Dr. Rupert Turnbull Jr.

Dr. Turnbull (1913–1981) became a colorectal pioneer when, as a surgeon with the Cleveland Clinic, he succeeded in developing a surgical procedure known as the colostomy, a stomach opening for the intestines. Dr. Turnbull joined the Cleveland Clinic after World War II service as a surgeon. He was a specialist on ulcerative colitis but realized the need for continued post-operative care once a colostomy had been performed and developed the idea for enterostomal therapy for his patients. Dr. Turnbull published extensively on his findings and coauthored the *Atlas of Intestinal Stomas*. He remained with the clinic as head of the Department of Colon & Rectal Surgery until 1978.

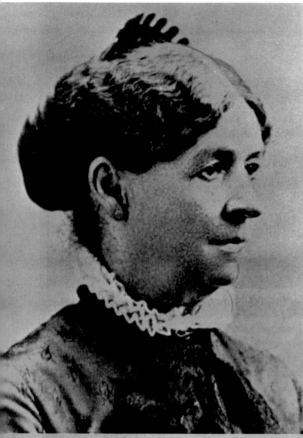

Dr. Myra King Merrick
Dr. Merrick (1825–1899) was Ohio's first female physician. She received her degree in 1852 from Central Medical College in New York then came to Cleveland and opened her private practice. In 1867, she helped found the Homeopathic College for Women, and in 1878 she also helped found a free medical and surgical clinic for women and children that would become Woman's General Hospital.

Lakeside Hospital Army Nurses
World War I saw many nurses volunteering to help the soldiers and to serve. Members of a 78-nurse unit from Lakeside Hospital are pictured returning after two years overseas. The unit was organized in 1917, before the United States entered the war, so it could be ready to move should the country enter the fight. The unit stopped in England on the way home and was welcomed by the King of England.

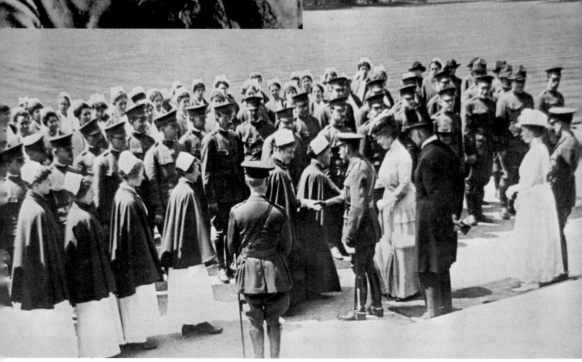

Frances Payne Bolton, Champion of Women
Clevelander Frances Bolton (1885–1977) was a career politician who served from 1939 to 1968 as a Washington, DC, congresswoman, lending her support to projects in health, education, nursing, and foreign affairs. She volunteered with the Visiting Nurse Association in 1904 and continued an interest in nursing from then on. Through Bolton's persistence, an Army School of Nursing was created during World War I to give volunteers professional training. In 1935, Bolton funded what would become the Frances Payne Bolton School of Nursing, as she believed nurses should have medical training and a college degree to elevate the profession as a legitimate career.

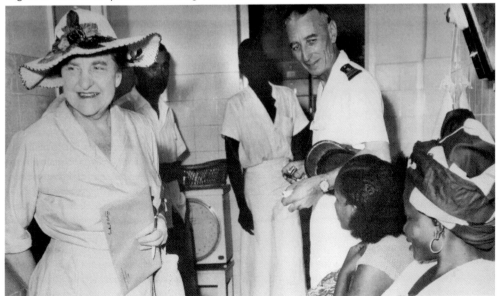

Frances Payne Bolton, Humanitarian
Congresswoman Bolton toured a hospital in West Africa as part of a three-month survey mission she undertook in 1955. She was the first congresswoman from Washington, DC, to travel to Africa. Bolton then presented a report to the House Foreign Affairs Subcommittee on the state of Africa.

Dr. Benjamin Spock
Dr. Spock (1903–1998) was an internationally renowned pediatrician who influenced a generation of new parents on how to raise their children. In 1946, he published *The Common Sense Book of Baby and Child Care*, the bible for bringing up happy, well-adjusted children. From 1955 to 1967, Dr. Spock was a professor of child development at Case Western Reserve University. He then retired from teaching.

Dr. Harland G. Wood
Dr. Harland Wood (1907–1991) was a renowned expert in the field of cell biology. His breakthrough discovery came in 1935 when he found that all living creatures used carbon dioxide in their cells. As a result of his findings linking the fields of biology and chemistry, treatment for metabolic diseases were refined and made more effective. Dr. Wood joined the faculty of Case Western Reserve University Medical School in 1946, where he taught and led the department of biochemistry until 1967. He was the recipient of numerous awards for his pioneering work.

Dr. Arthur Bill

Dr. Arthur Bill (1877–1961) was a Cleveland-educated obstetrician who devoted his life to reducing the maternal mortality rate, particularly for lower-income women. To achieve that end, Dr. Bill founded an outpatient clinic in his home and, in 1906, merged his private practice with the city's Maternity Hospital to provide more professional care and to train doctors in obstetrics. By 1911, Dr. Bill and the Maternity Hospital joined forces with Western Reserve University to offer women medical services for childbirth. As a result, Maternity Hospital became part of the newly-opened University Hospitals in 1925. When Dr. Bill retired in 1948, maternal care had been dramatically improved.

Dr. Henry Gerstenberger

Dr. Gerstenberger (1881–1954) was a pediatrician instrumental in founding Rainbow Babies & Children's Hospital and the development of synthetic milk baby formula. Dr. Gerstenberger headed the pediatrics department at City Hospital in 1906 and worked to improve infant and child care for impoverished families. In 1911, he became the first director of a new charitable babies and children's hospital, which he helped finance with profits from his baby formula. In 1925, Babies Dispensary and Hospital merged with University Hospital. The result was superior care for newborns and children.

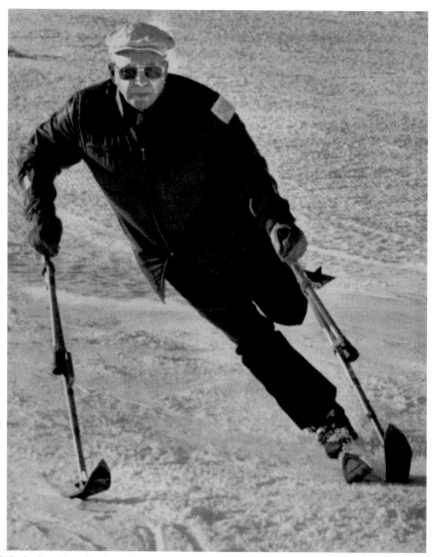

Paul E. Leimkuehler, Father of Three-Track Skiing
Paul Leimkuehler (1918–1993), a native Clevelander and graduate of Ohio State University, was an army second lieutenant during World War II when, during the Battle of the Bulge, he lost his left leg. Undaunted by the loss, Leimkuehler decided to create his own artificial limb. The resulting success led to the Leimkuehler Limb Company, which he opened on Cleveland's West Side in 1948. Emerging as a leader in the field, Leimkuehler expanded operations and opened PEL, a subsidiary supply company, on Detroit Avenue in Cleveland. In college, Leimkuehler had been a star athlete and, therefore, he was not satisfied making limbs just for everyday mobility. He wanted to be active in sports and set about to make it possible for amputees to ski. As a member of the Prosthetics Research Board for the National Academy of Sciences, Leimkuehler set about making skis that would put the disabled on the slopes. The result, as seen above, was three-track skiing, in which Leimkuehler attached skis to the ends of crutches that had been modified as ski poles. The genius was in the simplicity of the concept, one that allowed an amputee to ski by making the arms do double-duty in providing the necessary balance and rotation. As a result of his design, amputees could engage in downhill skiing. For his pioneering efforts, Leimkuehler was placed in the US Ski Hall of Fame in 1981 and the National Disabled Ski Hall of Fame in 1996.

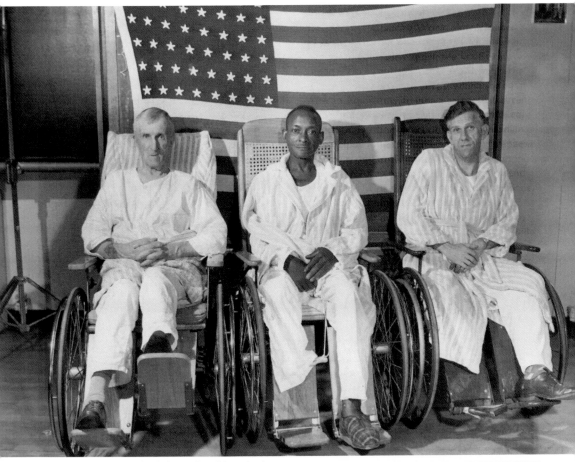

Crile Veterans Administration Hospital

Representing the cost of war are, from left to right, Jacob Barrick, Spanish-American War veteran; Lawrence Reynolds, World War I veteran; and Rollin Hudson, World War II veteran. The hospital was named in Dr. Crile's honor for his service in the Army Medical Corps during the Spanish-American War and World War I. The veterans here, all heroes, benefit from the dedication and work of people like Leimkuehler, Crile, and Rammelkamp.

Dr. Charles H. Rammelkamp

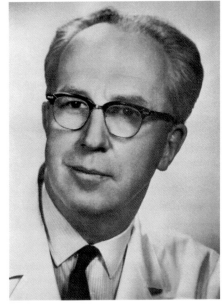

Dr. Rammelkamp (1911–1981), a specialist in epidemiology and preventive medicine, discovered that rheumatic fever was caused by streptococcus bacteria. It was 1948 when Dr. Rammelkamp, working with the Army's streptococcal disease department, studied soldiers with sore throats and discovered the link between the infection and rheumatic fever. With enough penicillin administered when strep throat is diagnosed, rheumatic fever can be avoided.

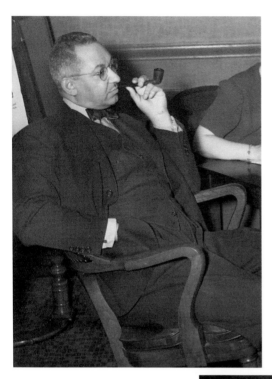

Dr. Charles H. Garvin

Dr. Garvin (1890–1968) was a Cleveland physician who became the first African American commissioned in the US Army medical corps during World War I. He wrote about his wartime experience and of African Americans in medicine, particularly in Cleveland, where he practiced medicine until his death. Dr. Garvin was also a businessman who helped found the Dunbar Life Insurance Company and the Quincy Savings & Loan Company. As a civic leader, Dr. Garvin became involved in helping city residents culturally and socially and was a trustee of Karamu House, the Urban League of Cleveland, and the Cleveland Public Library. (Cleveland Public Library Photograph Collection.)

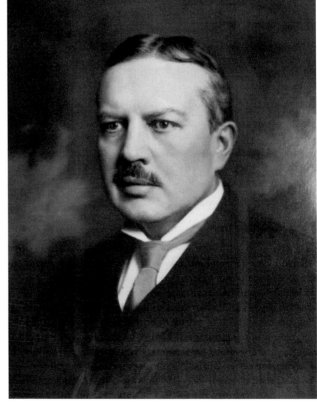

Dr. Carl August Hamann

Dr. Hamann (1865–1930) came to Cleveland in 1893 as a skilled surgeon who developed the reputation of having contributed more charity work as a visiting surgeon at Charity Hospital, where he was chief surgeon, and City Hospital, than any other physician. In addition to his outstanding community service, Dr. Hamann joined Western Reserve University Medical School to teach anatomy, becoming department dean in 1912 and dean of the medical school in 1916. He founded an anthropology museum at the school that contained an impressive collection of mammal skulls. In 1930, Dr. Hamann was posthumously awarded the Cleveland Medal for Public Service for putting the needs of patients ahead of any financial reward.

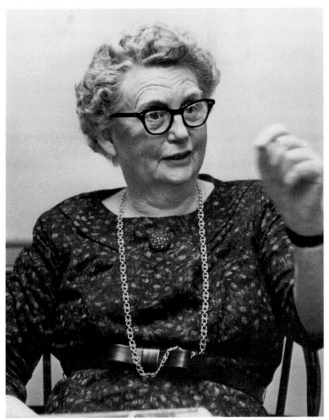

Mabel Woodruff

During World War I, Mabel Woodruff (1893–1963) gained field experience as an army rehabilitation volunteer in the medical corps, which she then turned into a career dedicated to improving the quality of care for institutionalized mental health patients. Woodruff came to Cleveland in 1922 and found work at Lakeside Hospital and City Hospital. She was a pioneer in the emerging profession of psychiatric social work and, by 1935, was able to open Ingleside Hospital to treat the mentally ill and build it into one of the best mental institutions providing care of the highest quality.

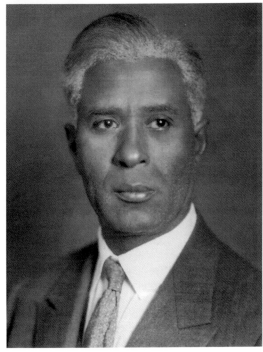

Garrett A. Morgan

Garrett Morgan (1877–1963) was an African American inventor who created a breathing apparatus, or gas mask, which he used to rescue workers trapped in Cleveland's waterworks tunnel disaster of 1916. An explosion under Lake Erie killed 12 workers and trapped many more. Morgan entered the tunnel wearing the mask and helped free the men. Morgan had little formal education when he came to Cleveland in 1895, but he was driven and creative. His numerous patented inventions include the gas mask (1914) and a hand-operated traffic signal (1923) that used three lights to indicate stop, go, and warning.

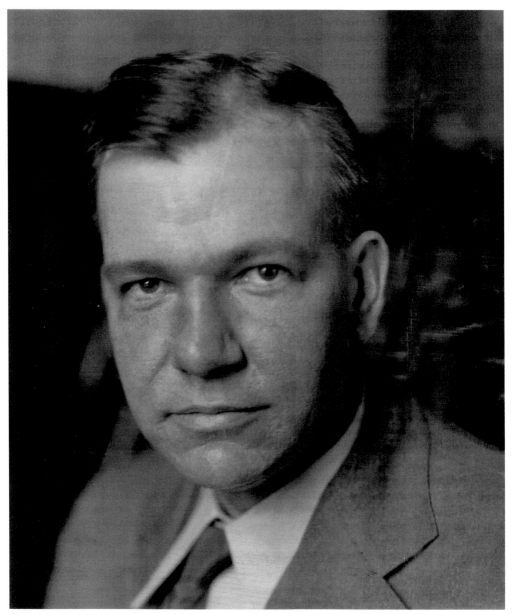

Dr. Claude S. Beck, Pioneer Heart Surgeon
There is a reason Cleveland landed on the map as the premiere location for the finest in cardiovascular care, and the reason is Dr. Claude Beck (1894–1971), renowned heart surgeon and inventor of the first heart defibrillator, a device that used simple electric shocks to restore heartbeat. Dr. Beck established his reputation in 1935 when, for the very first time, surgery was used to treat heart disease, particularly in the repair of damaged muscle and tissue and running a bypass when veins or arteries were clogged. Dr. Beck graduated from Johns Hopkins University Medical School in 1921 and completed his surgical residency as a Crile research fellow at University Hospitals in Cleveland. He would continue as a surgeon at University Hospitals until his retirement in 1965. He was the first to teach cardiovascular surgery and train not only physicians but other health professionals in the technique of heart defibrillation. Dr. Beck remained a professor at the Western Reserve University Medical School until he retired.

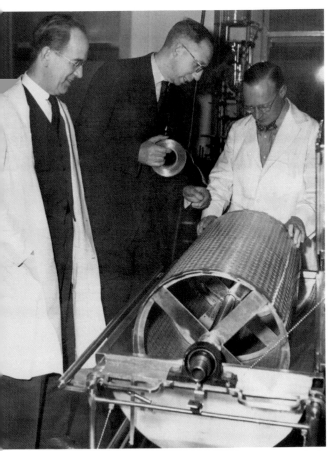

Dr. Irvine Heinly Page

Dr. Page (1901–1991) was a pioneer in the study of hypertension and atherosclerosis, or hardening of the arteries. In 1946, Dr. Page joined the Cleveland Clinic as director of research and strove to raise public awareness as to the effectiveness of using proper medication to reduce high blood pressure. In 1950, Dr. Page (far left) looks on as Dr. Willem J. Kolff (center) inspects his invention, an artificial kidney machine, at the clinic. The relationship between hypertension and kidney function was beginning to be explored and both Dr. Page and Dr. Kolff would publish extensively in their fields.

Dayton Clarence Miller

Dayton Miller (1866–1941) was a physicist who pioneered the use of X-rays to produce the first full image of a human body—his own. Professor Miller chaired the Physics Department at Case School of Applied Science from 1895 to 1936. He is pictured here with his surgical X-ray device, which used Crookes Tubes and 12 wet-cell batteries. For his contributions to physics, Miller won the Chamber of Commerce Medal in 1928.

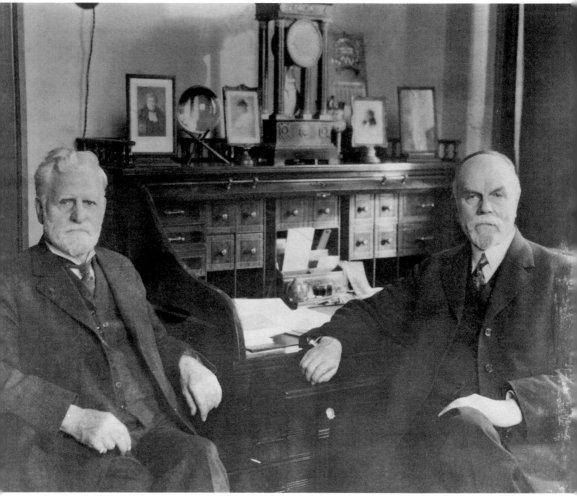

Warner & Swasey

Worcester R. Warner (1846–1929), pictured on the right, and Ambrose Swasey (1846–1937) were machinists and engineers who partnered in the founding of the Warner & Swasey Company in 1900 and achieved recognition and success for designing telescopes, astronomical instruments, and machine tools. They came to Cleveland in 1881, by way of Chicago, with the express purpose of establishing a machine-tool company. Warner's interest in astronomy led the company to manufacture telescopes, including large astronomical telescopes for observatories. Warner and Swasey met in 1869 when both worked for Pratt & Whitney in Connecticut. In 1880, they moved to Chicago to set up their machine-tool business. They then moved to Cleveland because it had more skilled mechanics and better manufacturing centers. Cleveland's lakefront location made it a magnet for new industries. Swasey was an engineer who designed gear-cutting machinery and then astronomical instruments. He helped found the American Society of Mechanical Engineers. Swasey was also a philanthropist who believed in higher education and donated nearly $1 million to the New York Engineering Society to create a research foundation. Warner donated a refractor telescope to Case Western Reserve University. A second Warner & Swasey telescope is located at the Cleveland Museum of Natural History. Both remained active in civic, scientific, and professional societies and wrote extensively on their work.

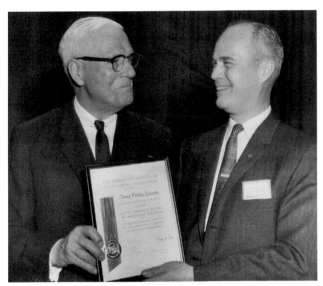

James F. Lincoln

James Lincoln (1883–1965) was an engineer, an inventor, and the head of Lincoln Electric Company. He had a degree in electrical engineering and, in 1907, joined Lincoln Electric, his brother John's company. He became general manager in 1914 and, upon his brother's retirement, served as the company's president from 1928 until 1954. As an inventor, Lincoln had 20 patents, many dealing with innovations in welding metal. In this photograph, Lincoln (left) is honored for his outstanding management ability.

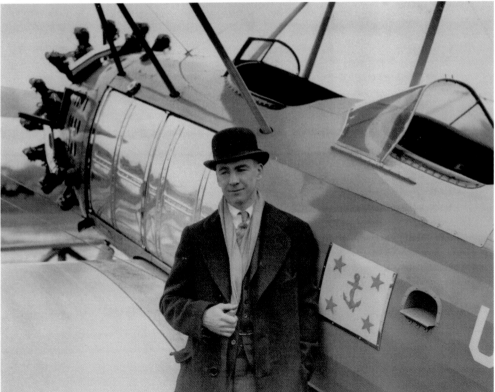

David S. Ingalls Sr., "Flying Ace"

David Ingalls (1899–1985), a Clevelander, stands beside a Sopwith Camel airplane, the type of craft he flew for the US Navy during World War I when he shot down four enemy planes and three aerial balloons. His record made him the navy's sole flying ace and he was awarded the Navy Distinguished Service Medal. During World War II, Ingalls re-enlisted as an aviation specialist. He was inducted into the National Aviation Hall of Fame in 1983.

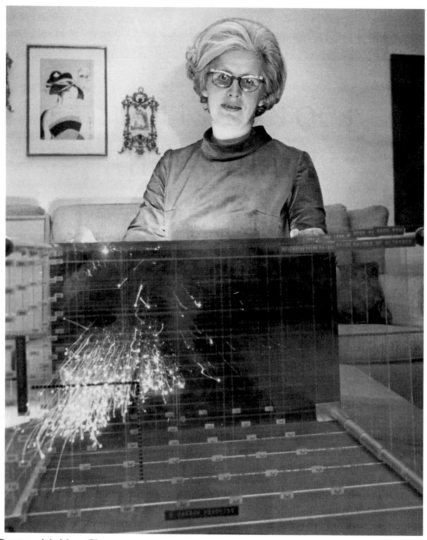

Fight Smog with Mrs. Chew

Marian Friend Chew was a chemist, mathematician, statistician, and homemaker who spent two months making a model, seen here in 1969, composed of 1,039 threads to show the smog emission of one car. She wanted to create a speedy, inexpensive method of testing individual cars for smog or pollutants and avoid the lengthy 12 hour tests to check for pollutant emissions. She chose Los Angeles to test her device, as the smog there remains legendary. Her first work on the LA smog problem occurred between 1955 and 1958, when Sohio, for whom she worked as a researcher, named her one of its representatives to a coordinating research council in New Jersey. After a period of profitless research, Chew took a short break period to be with her family. In 1966, she resumed work on the problem at home, mathematically, with the old data she had accumulated before. Using plastic tubing and empty Clorox bottles, she developed a test that involved simply inserting a long hose with a probe on it at least 12 inches into the tailpipe. The hose was then connected to two battery-operated instruments that measured the levels of carbon monoxide and hydrocarbons emitted. The test was 80 percent accurate. She presented her first paper on the idle inspection in 1969 to the Society of Automotive Engineers Congress. She patented her invention, which allows the driver to remain in the car while the test is administered. Thanks to Chew, a cheap, quick way to fight smog was invented in a kitchen.

Vincent Marotta and Mr. Coffee

Who doesn't love the aroma of coffee in the morning? Thanks to Cleveland businessman Vincent G. Marotta, inventor of the best-selling coffee brewing system, Mr. Coffee, stovetop and electric percolators have been set aside in favor of this new system activated by the push of a button. Marotta was named a winner of the 1975 Horatio Alger Award, which recognizes hard work, honesty, and adherence to traditional ideals.

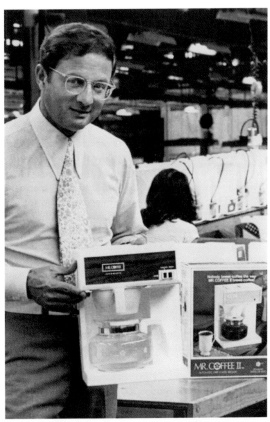

Joseph F. "Joe" Hrudka, "Mr. Gasket"

Joe Hrudka was a two-time National Hot Rod Champion (1961 and 1962) when he determined that automobile performance could be improved with better gaskets and seals. Through trial and error, Hrudka developed a gasket made of asbestos to help cars run smoother and save owners on gasoline. In 1964, at age 24, Hrudka founded "Mr. Gasket" and set up headquarters in Brooklyn, a suburb just west of Cleveland. At its peak performance, Mr. Gasket saw annual sales of nearly $80 million.

David Dietz

David Dietz (1897–1984) was the science and medicine editor and Pulitzer Prize–winning columnist for the *Cleveland Press*. Popular with readers because of his ability to explain science and medicine in simple language, Dietz began his 50-year career with the paper in 1921 while a student at Western Reserve University. His column appeared daily in 1922, and in 1934 Dietz became the first president of the National Association of Science Writers. He shared the Pulitzer Prize in 1937 for his coverage of scientific meetings at Harvard. Dietz was a prolific and compelling writer who had the ability to rally others for a cause. He displayed this talent in 1923 when he launched a movement to have a statue of Abraham Lincoln erected in Cleveland. As Dietz relays the story, *Cleveland Press* editor H.B.R. Briggs asked Dietz why the city did not have a statue of Lincoln, as all other major cities had. "If you want one, I'll get it," replied Dietz. Using the power of the press, Dietz launched the campaign for a Lincoln statue with a front-page article calling for a commission to be formed and funds raised for the project. Fred Kohler, then mayor of Cleveland, gave Dietz permission to form a commission that included some of the most influential people of the day. Soliciting the help of schoolchildren, over $35,000 was collected for the Lincoln statue. In 1927, Max Kalish was commissioned to sculpt Lincoln. Such was the influence of Dietz and the press. Dietz served in World War II on a committee of the Office of Scientific Research & Development. He reported on the atom bomb test at Bikini Atoll and, in 1945, wrote his first book, *Atomic Energy in the Coming Era*. Dietz continued to write, winning numerous awards and honors.

CHAPTER FOUR

Sports Heroes
and Villains

Cleveland loves its sports teams and athletes. Whether it is baseball, football, basketball, hockey, field hockey, the Olympics, tennis, or even marbles, fans love to watch the competition and cheer on the winners, especially when they represent Cleveland. The Cleveland Indians gave baseball fans some of their most memorable summers. Sometimes the memories were tragic, as when popular shortstop Ray Chapman died as the result of a bad pitch. And everyone remembers Rocco Scotti as he belted out his version of the national anthem in the old Cleveland Municipal Stadium. Stella Walsh showed just how far women could excel in sports, and Paige Palmer made it possible for the average housewife to be fit and trim. Arthur "Mickey" McBride gave Cleveland the Browns, and Art Modell took them away to Baltimore. Nick Miletti built arenas, and Don King filled them. Through it all, Cleveland fans remain loyal to their teams and their heroes. Cleveland is truly a sports town.

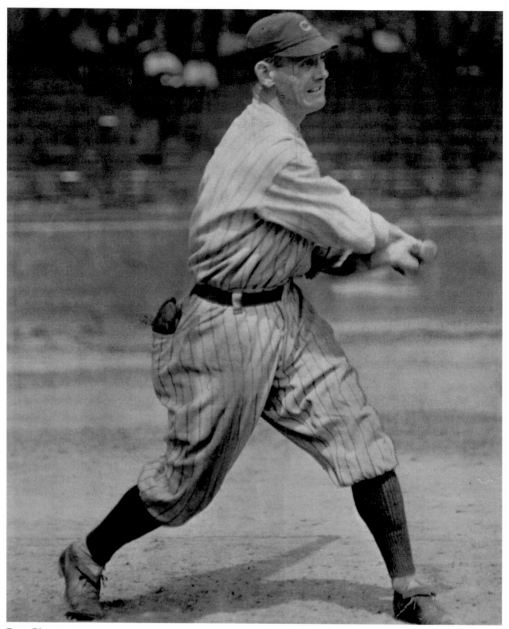

Ray Chapman

"Do it for Ray!" was the *Cleveland Press* rallying cry as baseball fans cheered the Cleveland Indians to victory when the team became world champions in the summer of 1920. It was the first time the Indians had won the title and their inspiration was Raymond Johnson "Ray" Chapman (b. 1891) who, in 1912, joined the Indians as shortstop and gained a place in baseball legend when he became the last player to die from a wild pitch during a game. The Indians were playing the New York Yankees in New York when Chapman was at bat and took a ball directly to the head from pitcher Carl Mays. Chapman fell and was taken to a hospital nearby, where he died 12 hours later, on August 17, 1920. Only 29 years old, Chapman had been a fan favorite and thousands attended his funeral in Cleveland. Public outcry over the loss of such a talented player led to new rules for pitching. Carl Mays continued to pitch in the major leagues for many years.

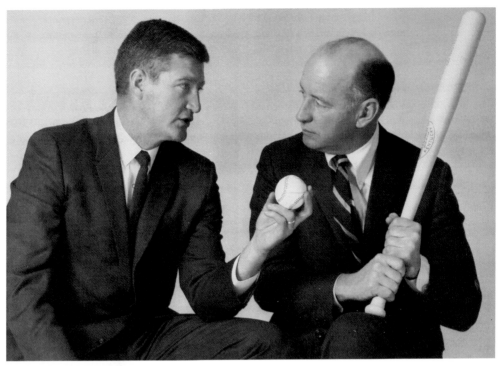

Herb Score and Bob Neal

Herb Score (1933–2008) was the play-by-play announcer for the Cleveland Indians for more than 30 years. Score was first a Major League baseball player who made his debut as a pitcher with the Indians in 1955. But a wild hit on the field playing against the New York Yankees in 1957 nearly cost him an eye and ended his playing career. Score recovered and went on to become a legendary and beloved Indians announcer for radio and television. He is seen here with fellow sportscaster Bob Neal (right).

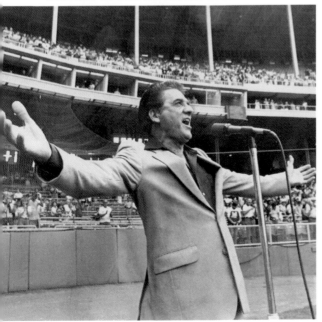

Rocco Scotti

No Cleveland Indians game was complete without the sonorous tones of Rocco Scotti (b. 1920) singing "The Star-Spangled Banner" before a crowded Cleveland Municipal Stadium. The immensely popular tenor realized he had vocal talent and moved for a time to New York for proper operatic training. Returning to Cleveland after the Indians won the 1948 World Series, he received requests to sing the anthem at various sporting events. But Scotti's rendition of the national anthem for the Indians made the summer for most. He continued singing for the team until the early 1990s.

Stella Walsh

Stella Walsh (1911–1980), pictured in the center of the top row, was considered the greatest all-around female athlete of her day after amassing an astounding number of medals and trophies, numbering about 5,000. She broke nearly every record in every track and field event she entered in America, Europe, Asia, and Africa. Walsh was a sports phenomenon. Born Stanislawa Walasiewicz, Walsh was a small child when she moved with her family to Cleveland from her native Poland. Walsh distinguished herself in athletics in high school and when she was 17, she was invited to join the US women's Olympic track team. As she was still a Polish citizen, she could not. In 1932, Walsh participated in her first Olympics as part of the Polish track team, winning the 100-meter dash and the gold medal in Los Angeles. Walsh continued to compete long after many athletes of her generation had retired. By 1946, she held over 60 world and national records. She became an American citizen in 1947 and turned her attention to coaching. In 1980, Walsh was killed by a stray bullet during a botched robbery shortly before Christmas. In the February 12, 1981, issue of the *Plain Dealer*, the autopsy report by Dr. Samuel Gerber revealed that Walsh had both male and female organs—the result of a rare genetic disorder—but "lived and died a female."

Mary Kendall "Brownie" Browne

Mary Browne (1891–1971) would answer the question of whether a woman can have it all with a resounding "yes!" Browne refused to conform to stereotypes and spent her life in the roles of teacher, businesswoman, war volunteer, and even artist. But the native Californian will be best remembered as a champion tennis player and golfer. She became a singles and doubles champion and won her first national tennis title in 1912. Upon moving to Cleveland during the Great Depression, she went into business for herself and took up golf. She would win the Cleveland Women's Amateur Golf Championship four times during the 1930s and the state golf title three times. Browne was inducted into the halls of fame for both tennis and golf.

Paige Palmer, "First Lady of Fitness"
Paige Palmer (1916–2009) spent 19 years on WEWS-TV hosting her own production, *The Paige Palmer Show.* During the daily physical exercise program, Palmer wore a leotard and her trademark black fishnet stockings (heels optional). Her show was first scheduled to run only 13 weeks, but her popularity took off and Palmer became a mainstay for nearly two decades. Palmer was born Dorothy Rohrer in Akron. Physical fitness was part of her family routine, and she learned to swim by age two. She majored in physical education in college then moved for a time to New York, where, in 1944, she had a brief stint in television costuming models. Returning to Cleveland, she became the exercise queen of television and remained so until she retired from the station in 1971. She also authored a book called *Fitness Is a Family Affair.*

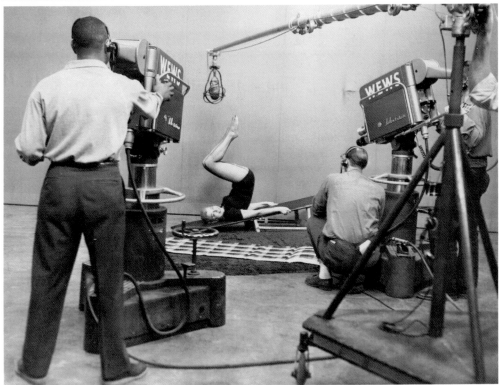

Arthur B. "Mickey" McBride
Arthur McBride (1888–1972) founded the Cleveland Browns football club in 1944 as part of the All-American Football Conference. In 1945, he hired Paul E. Brown as his head coach. A local radio contest led to the name Browns for the franchise. In 1949, McBride moved the Browns to the NFL and, in 1953, he sold the team to a group of investors for $600,000, the largest sum paid at the time for any franchise. McBride was a savvy businessman who expanded his holdings to include real estate and taxi cabs, but his legacy will always be tied to the Browns.

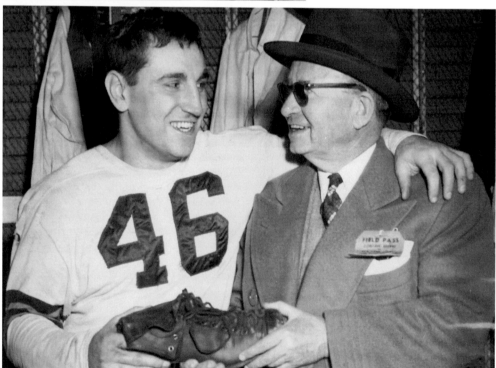

Lou "The Toe" Groza
Lou Groza (1924–2000), who kicked the field goal enabling the Cleveland Browns to emerge victorious in the American Conference Championship playoff game against the New York Giants at Cleveland Municipal Stadium, is pictured in 1950 with the president and owner of the Browns, Mickey McBride. The two are holding Groza's kicking shoe in the dressing room after the Browns beat the Giants by a score of 8-3.

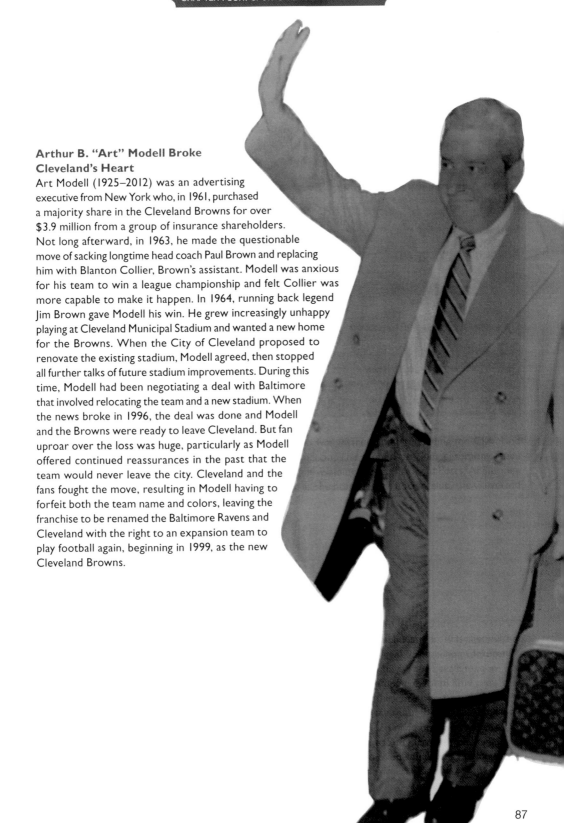

Arthur B. "Art" Modell Broke Cleveland's Heart

Art Modell (1925–2012) was an advertising executive from New York who, in 1961, purchased a majority share in the Cleveland Browns for over $3.9 million from a group of insurance shareholders. Not long afterward, in 1963, he made the questionable move of sacking longtime head coach Paul Brown and replacing him with Blanton Collier, Brown's assistant. Modell was anxious for his team to win a league championship and felt Collier was more capable to make it happen. In 1964, running back legend Jim Brown gave Modell his win. He grew increasingly unhappy playing at Cleveland Municipal Stadium and wanted a new home for the Browns. When the City of Cleveland proposed to renovate the existing stadium, Modell agreed, then stopped all further talks of future stadium improvements. During this time, Modell had been negotiating a deal with Baltimore that involved relocating the team and a new stadium. When the news broke in 1996, the deal was done and Modell and the Browns were ready to leave Cleveland. But fan uproar over the loss was huge, particularly as Modell offered continued reassurances in the past that the team would never leave the city. Cleveland and the fans fought the move, resulting in Modell having to forfeit both the team name and colors, leaving the franchise to be renamed the Baltimore Ravens and Cleveland with the right to an expansion team to play football again, beginning in 1999, as the new Cleveland Browns.

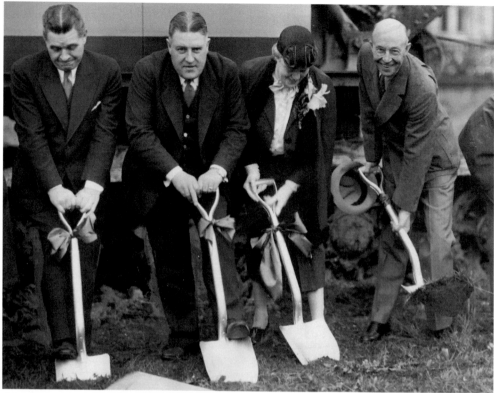

Albert C. "Al" Sutphin

Al Sutphin (1895–1974) was a successful businessman who was instrumental in building the Cleveland Arena, a 10,000-seat facility on Euclid Avenue, for $1.5 million. The ground-breaking ceremony (seen here) took place on May 17, 1927. Pictured from left to right wielding shovels are Fred Potts, Al Sutphin, Helen Braden, and Harry Holmes. Sutphin built the arena as the home for his hockey club, the Cleveland Barons, but all sporting events were welcomed.

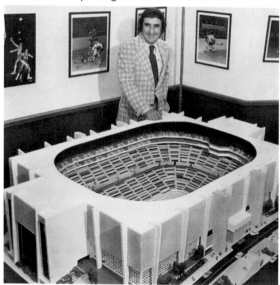

Nick J. Mileti

Cleveland native Nick Mileti (b. 1931), a lawyer and businessman, was the owner and president of three major Cleveland sports franchises: the Cavaliers, the Crusaders (a hockey club), and the Indians. In this 1974 photograph, Mileti is showing a model of the new $20 million Coliseum he would build just south of Cleveland to host sporting events and other attractions. Mileti also owned the Cleveland Arena, which he purchased along with the Barons in 1968.

John Patrick "Johnny" Kilbane
Cleveland's own Johnny Kilbane (1889–1957) was a world featherweight boxing champion, a title he held for 11 years. In this photograph from February 22, 1912, Johnny Kilbane is sitting in his corner with a jubilant smile after receiving the referee decision in his favor in the title fight for world featherweight champion after defeating now former champion Abe Attell after a grueling 20 rounds. Kilbane held the title until 1923, when he retired from boxing.

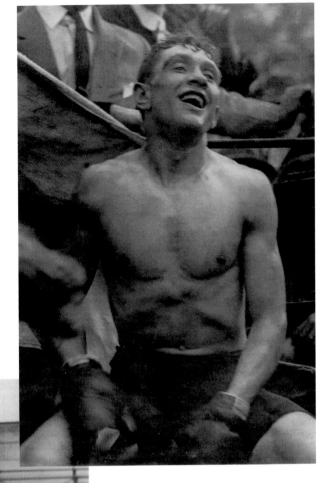

Donald "Don" King
Clevelander Don King (b. 1931) established himself as a legendary boxing promoter with his first staged fight set between Muhammad Ali and George Foreman. The televised event made King's name synonymous with the boxing world. King would go on to promote some of the biggest names and matches in boxing, including Sugar Ray Leonard and Mike Tyson, using now iconic taglines like "The Thrilla in Manila."

89

Ida Jean "The Champ" Hopkins

In 1951, Ida Hopkins (b. 1937) won the girls' division championship of the National Marbles Tournament held at Asbury Park, New Jersey. The Joint Recreation Board of Cleveland sponsored Hopkins, who had won the Press Marbles Tournament. Hopkins was Cleveland's first national marbles champion. She was presented with flowers and a certificate at a ceremony held at East Tech High School in her honor by chief of playgrounds Gus Kern (left) and recreation supervisor N.A. Focarett.

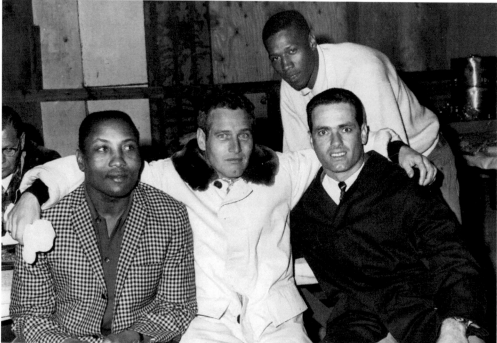

Paul Newman and Friends

During spring training in 1967, the Cleveland Indians had an unexpected visitor at their camp in Tucson, Arizona: Oscar-winning actor—and Indians fan—Paul Newman (1925–2008) who was in town to film his latest movie, *Hombre*. Flanking Newman are, from left to right, Leon Wagner, Rocky Colavito, and Chuck Hinton (rear). Newman grew up in Shaker Heights, a suburb of Cleveland, and graduated from Kenyon College. He then went on to become one of the finest dramatic actors in film. Before he became a star, Newman once had a small role as a New York Yankees player for television.

CHAPTER FIVE

Musicians, Artists, and Creative Folk

How many people know that the iconic Irish ballad "When Irish Eyes are Smiling" was written by Ernest Ball, a Clevelander? Or that *The Spirit of '76*, America's greatest patriotic painting, was the work of Archibald Willard, who was inspired to paint his definitive work after attending Fourth of July festivities in Cleveland? Then there is Leah Ballard, who spent years playing live piano as a sheet-music peddler and entertainer for Kresge's. The Cleveland Orchestra was led by some of the finest conductors, including Robert Shaw, Louis Lane, and George Szell. Carmela Cafarelli, harpist, and Eunice Podis, pianist, lent their exceptional talents to one of the finest orchestras in the world. Also remembered are top 40 WIXY 1260 and great disc jockeys like Billy Bass, who made the songs come alive and helped pave the way for Cleveland's designation as the rock-and-roll capital of the world.

Artists like Edris Eckhardt, Lydia Ames, Paul Travis, and Viktor Schreckengost all honed their unique styles here, and many had connections to the Cleveland Institute of Art, the city's outstanding art school. Sculptors Max Kalish and William McVey were the finest in their field and their works still stand in Cleveland today. Finally, we recognize Joseph Laronge and Rowena and Russell Jeliffe for bringing the theater scene to Cleveland when they founded, respectively, Playhouse Square and Karamu House.

Ernest R. Ball

Ernie Ball (1878–1927) was a musician and composer of songs that became very popular in his day. From 1904 until his death, Ball celebrated his heritage and family in memorable songs, his most famous perhaps being "When Irish Eyes Are Smiling." Ball received musical training at the Cleveland Conservatory then moved briefly to New York followed by touring as a pianist on the vaudeville circuit, where he honed his skills and wrote his songs.

Ohio Historical Marker

In 1966, this historical marker was placed in front of the Cleveland home of Ernie Ball at 1541 East Thirtieth Street to recognize the birthplace and honor the composer for a truly memorable music career. It names some of his most famous compositions, including "Mother Machree" and the iconic ballad "When Irish Eyes Are Smiling."

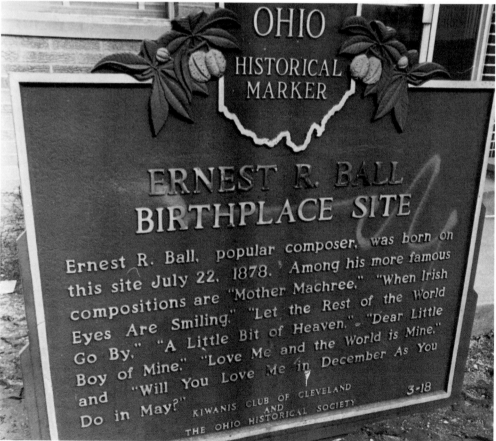

OHIO HISTORICAL MARKER

ERNEST R. BALL BIRTHPLACE SITE

Ernest R. Ball, popular composer, was born on this site July 22, 1878. Among his more famous compositions are "Mother Machree," "When Irish Eyes Are Smiling," "Let the Rest of the World Go By," "A Little Bit of Heaven," "Dear Little Boy of Mine," "Love Me and the World is Mine," and "Will You Love Me in December As You Do in May?"

KIWANIS CLUB OF CLEVELAND
AND
THE OHIO HISTORICAL SOCIETY 3-18

Leah Ballard

It is 1958 in this photograph, and for the past 24 years, for six days a week, from 9:30 a.m. to 5:45 p.m., Leah Ballard played an average of 250 songs a day, 350 on Mondays and Thursdays when she worked until 9:00 p.m. in Kresge's at 216 Euclid Avenue. Ballard was the only remaining live piano sheet music sales lady, or "song plugger"—not only in Cleveland, but in all the Kresge stores nationwide. Before radio and Muzak filled customers' ears, department stores hired musicians to plug songs. Many times, the composers would surprise her with an appearance, and they would entertain customers with popular songs. Ballard never kept a piano at her home.

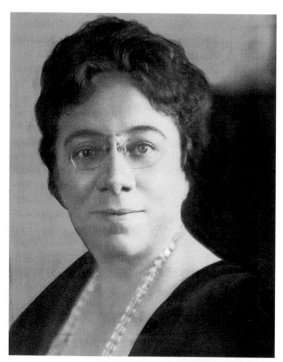

Lila Robeson

Lila Robeson (1880–1960) was a contralto who became a renowned opera singer even though she bypassed European training to study opera in New York. Robeson was also the first Cleveland singer to make a career with the New York Metropolitan Opera, singing with the company from 1912 to 1922. She then returned to Cleveland, where she opened a music studio and taught voice.

Carmela Cafarelli

Carmela Cafarelli (1889–1979) was the first harpist with the Cleveland Orchestra and an accomplished opera singer. She began playing at age 12, performing with various companies until 1918 when she joined the Cleveland Orchestra. After three years, she left to study opera in Italy. She returned to Cleveland and established the Cafarelli Opera Company, for which she sang leading soprano roles.

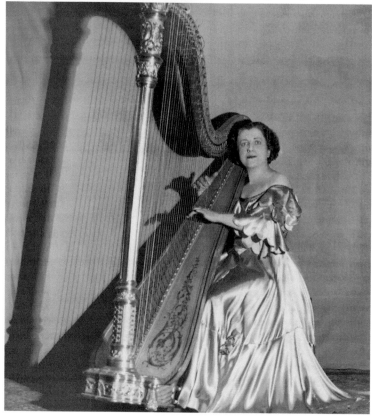

The Three Conductors: Shaw, Szell, and Lane
The Cleveland Orchestra, one of the top five orchestras in the world, has had only the finest conductors and guest conductors lead the musicians at Severance Hall. Pictured here are three of the best. From left to right are Robert Shaw (1916–1999), George Szell (1897–1970), and Louis Lane (b.1923). Szell tenured with the Cleveland Orchestra for 24 years; under his direction, it achieved world-class status.

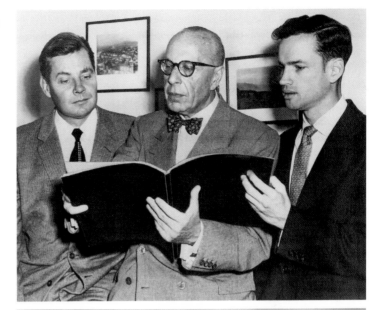

Eunice Podis
Eunice Podis (1922–2008) was a classical pianist and an instructor at the Cleveland Institute of Music for 30 years. Podis earned the distinction of having appeared as a guest soloist with the Cleveland Orchestra more than any other pianist, according to the *Cleveland Jewish News*. Her first appearance was in 1941. She was featured on many orchestra recordings and had played Carnegie Hall. She is pictured here with conductor Leonard Bernstein.

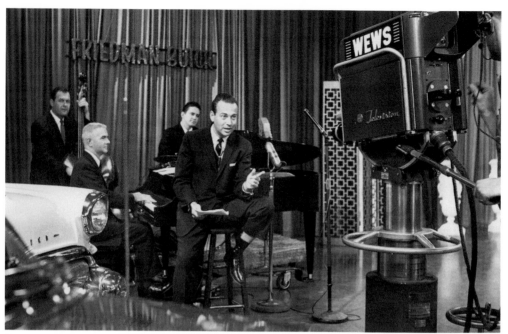

Norman Wain

Norman Wain shook up Cleveland-area radio in 1965 when he boldly inserted rock music at the 1260 spot on the local AM dial. As Wain told the *Plain Dealer* in 1971, "everybody thought we were crazy." The "we" were his partners Joe Zingale and Bob Weiss. Not only did WDOK-FM's pop tunes disappear, but the call letters were switched to WIXY. Under Wain, WIXY has consistently led the pack in the top-ranked pop market. He is pictured here in front of a television camera. (Cleveland Public Library Photograph Collection.)

Billy Bass

One of the reasons WIXY 1260 was number one in Cleveland was on-air talent like the hugely popular Billy Bass, the first black disc jockey at a top 40 radio station. When Norman Wain hired Bass, a Clevelander, in 1969, he was taking a chance since white teenagers comprised the core audience. But it proved to be well worth the risk when a radio promotion held at Lakewood High School featuring the WIXY Supermen, as the disc jockeys were called, found the students cheering wildly and enthusiastically for Bass, who was clearly their favorite. Bass held the 6:00–10:00 p.m. slot for two years before he moved onto WMMS-FM radio, where he continued Wain's mission to make music fun in Cleveland.

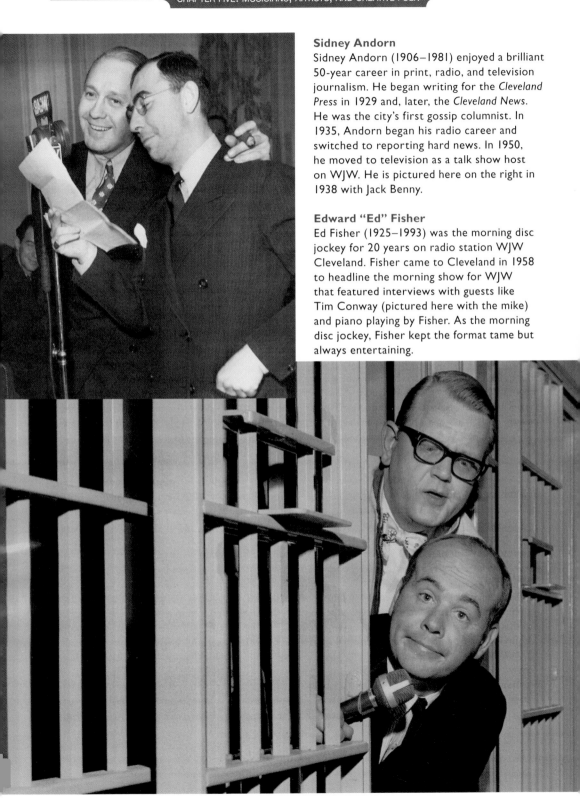

Sidney Andorn

Sidney Andorn (1906–1981) enjoyed a brilliant 50-year career in print, radio, and television journalism. He began writing for the *Cleveland Press* in 1929 and, later, the *Cleveland News*. He was the city's first gossip columnist. In 1935, Andorn began his radio career and switched to reporting hard news. In 1950, he moved to television as a talk show host on WJW. He is pictured here on the right in 1938 with Jack Benny.

Edward "Ed" Fisher

Ed Fisher (1925–1993) was the morning disc jockey for 20 years on radio station WJW Cleveland. Fisher came to Cleveland in 1958 to headline the morning show for WJW that featured interviews with guests like Tim Conway (pictured here with the mike) and piano playing by Fisher. As the morning disc jockey, Fisher kept the format tame but always entertaining.

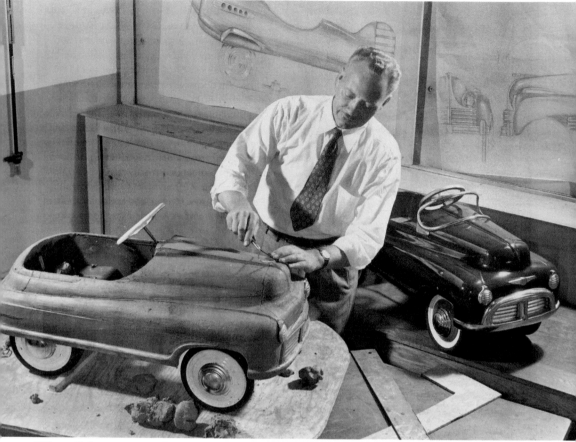

Viktor Schreckengost, Renaissance Man

Viktor Schreckengost (1906–2008) was an industrial engineer who was acclaimed for his many diverse and unique artistic talents and for whom the title Renaissance Man is apt. Originally from Alliance, Ohio, Schreckengost moved to Cleveland to study at the Cleveland School of Art (now Cleveland Institute of Art) and graduated in 1929. He was a restless artist who moved from one medium to the next, always experimenting, always improving. During a career that spanned over 70 years, Schreckengost was a painter (using oils and watercolor), a sketch artist, sculptor and potter, and an industrial designer with a limitless imagination that he used to create toy cars, trucks, and bicycles for children. He was in demand as an innovator and designed chairs, fans, flashlights, and even dinnerware for such companies as Sears and White Motors. Schreckengost spent over 50 years teaching and creating in his studio (above) at his alma mater, where he founded an industrial design department. In 2006, Schreckengost was awarded for his talent and genius with the National Medal of Arts by Pres. George W. Bush.

Viktor Schreckengost at the Zoo

Schreckengost was commissioned by the Cleveland Zoological Society in 1956 to create this relief of elephants for the pachyderm exhibit. It was a tremendous undertaking; however, in the skilled hands of this sculptor, mother and baby elephant are wonderfully portrayed as emerging from the wall in mid-relief.

"White Antelope"

In 1954, Viktor Schreckengost's ceramic "White Antelope" won first prize and $500 at the 18th Ceramic National Competition sponsored by the Syracuse Museum of Fine Arts and the Ferro Corporation of Cleveland. Schreckengost impressed judges with his glazed stoneware and wonderful flow of line.

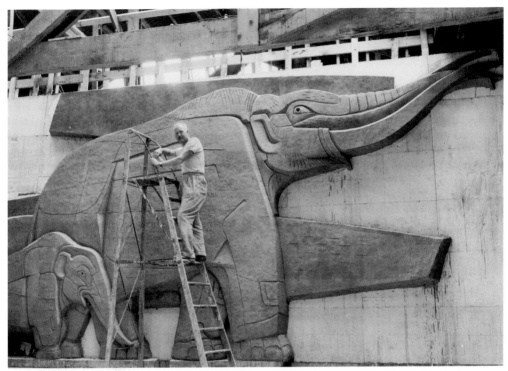

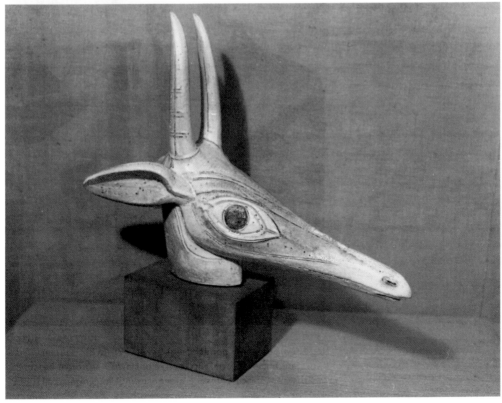

George Gustav Adomeit

George Adomeit (1879–1967) was an artist specializing in printing and engraving who, in 1913, founded the Cleveland Society of Artists. Adomeit moved to Cleveland from Germany and studied drawing at the Cleveland School of Art (Cleveland Institute of Art) on scholarship. He developed an interest in lithography, which led him to chair the school's photoengraving department and, in 1937, establish and become president of the Caxton Engraving Company. Adomeit wanted to give students the kind of opportunity he had to attend the art institute and created a scholarship fund. His talents extended to painting and drawing, with some of his works appearing in the Cleveland Museum of Art.

Lydia May Ames

Lydia Ames (1863–1946) was one of a small group of women artists in Cleveland and the first to achieve national recognition for her work—a collection of oil landscapes done in the impressionist style that was popular at the time. Ames graduated from the Cleveland School of Art (Cleveland Institute of Art) in 1900. (The school was founded by several Cleveland women in 1884.) Ames painted her landscapes in miniature, no larger than a postcard, and met with such success that she exhibited in major art venues. She taught for over 25 years at her alma mater and maintained a private studio where she continued to teach after retirement.

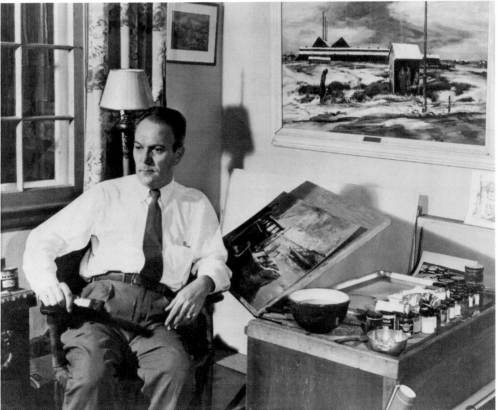

Carl F. Gaertner

Carl Gaertner (1898–1952) was an acclaimed landscape watercolorist. He was born in Cleveland and graduated from the Cleveland School of Art (Cleveland Institute of Art), where he began to teach in 1925. His paintings of Ohio landscapes gained national attention, and he exhibited in major galleries, including the Cleveland Museum of Art and the Metropolitan Museum in New York.

Hans Busch, "The Simple Things"
Hans Busch (1884–1952) was a German painter who won numerous prizes for Community Fund posters in the 1930s. Busch studied art and later taught at Berlin's Royal Academy of Fine Arts. He came to America in 1929 and began to design posters using simple lines and a medium of watercolor, tempera, and crayon. His first prize-wining poster depicted a mother cradling an infant with the slogan, "Give as a mother gives." Of his work, Busch said in 1929, "The simplest and best things are before us all the time; the difficulty is in recognizing that fact."

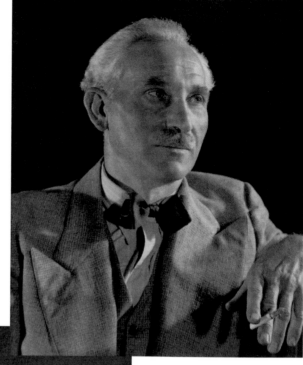

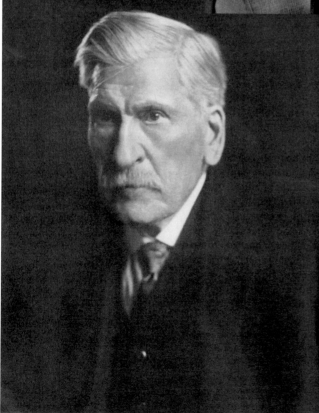

Archibald M. Willard, "Yankee Doodle Dandy"
Archibald Willard (1836–1918) was an Ohio artist best known for his painting *The Spirit of '76*, which commemorates American independence. Willard taught himself to draw and began painting portraits. After service in the Civil War, he supported himself with sketches and comical drawings. He moved to Cleveland in 1875 and, inspired by Fourth of July festivities, began painting his iconic trio of Revolutionary War musicians. His painting was displayed at the International Centennial Exposition in Philadelphia in 1876 and he became an acclaimed artist. Willard remained in Cleveland, where he founded the Art Club and inspired many future artists.

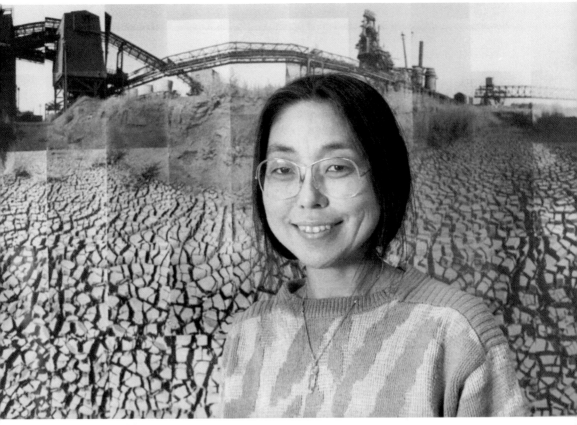

Masumi Hayashi

The death of an artist, particularly an accomplished visionary, always leaves society wondering what further works of genius were lost. In the case of Dr. Masumi Hayashi (1945–2006), a Japanese American artist, photographer, and professor at Cleveland State University, her tragic and untimely death left a void in the art world, particularly in the area of photographic collage art. Dr. Hayashi was born in Rivers, Arizona, in the Gila River War Relocation Camp at the end of World War II. Her family then moved to Los Angeles, where she attended school. Upon graduation from high school, Dr. Hayashi moved to Florida, where she received her undergraduate and graduate degrees in fine arts from Florida State University. In 1982, she joined the staff of the art department at Cleveland State University, where she taught photography. She was tenured in 1996. The style of photographic art preferred and popularized by Dr. Hayashi, and which brought her worldwide acclaim as an artist, is called composite photography. The technique involved taking anywhere from a handful to hundreds of panoramic pictures in a frame-by-frame manner so that each image was slightly different from the previous one and then re-assembling the images to form a new, much larger image. As seen in the work above, titled *Republic Steel Mill* (1988), the image looks at first glance like a large reproduction of a photograph but it is actually, as seen by the lines or creases, hundreds of fragments of the same image with variations in the camera angle to raise or lower the horizon line and produce a new image. Dr. Hayashi chose a wide array of subjects, which she grouped together in a series. The work here was part of her Post Industrial Landscape series and was shot in Cleveland. Dr. Hayashi had taught at CSU for 24 years when, on August 17, 2006, she was shot to death in her apartment building on Cleveland's West Side by a neighbor who turned violent when asked to reduce the noise from his apartment. A fellow artist and neighbor, John Jackson, was also killed. Dr. Hayashi's work appears in museums worldwide and she was the recipient of numerous awards, including the Cleveland Art Prize in 1994 for her series on internment camps.

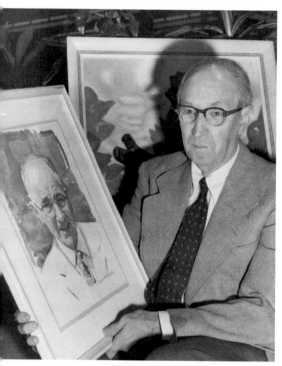

August F. Biehle Jr.

August Biehle (1885–1979) was a successful lithographer and a landscape and portrait artist. Born in Cleveland, Biehle left for Europe in 1903 to study painting at the Royal Academy of Fine Arts in Berlin. He returned to Cleveland in 1905 to continue independent art studies and to paint. In 1912, he joined Otis Lithography and worked as a lithographer until he retired in 1952. His paintings won numerous awards and were exhibited frequently in local shows.

William Sommer

William Sommer (1867–1949) was a painter and lithographer who studied in Europe and New York before coming to Cleveland in 1907. He worked as a lithographer and during the Depression painted murals for public buildings including the Cleveland Public Library and Public Hall. He became a huge fan of avant-garde art and actively promoted it whenever he exhibited his work in local shows.

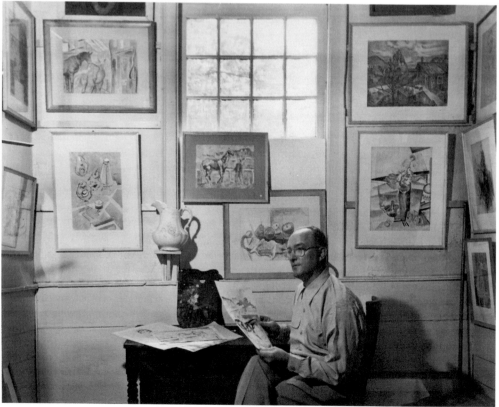

Paul B. Travis, Eye on the Tiger

Paul Travis (1891–1975) was another artist in the imaginative core of Cleveland artists who usually attended and later taught at the Cleveland School of Art (Cleveland Institute of Art). Travis graduated from the Cleveland School of Art in 1917 and taught at the school from 1920 until he retired in 1957. In 1927, he made a nearly yearlong and widely publicized expedition to Africa, collecting art and artifacts that he donated to the Cleveland Museum of Art and the Cleveland Museum of Natural History. The expedition served as inspiration for a series of works he did on tigers, as seen here. Travis worked in oils and watercolors and used these mediums to make his abstract tigers more fierce and brilliant, making them come alive. He toured as a lecturer and won nearly every local artist competition in the Cleveland area.

Edris Eckhardt

Edris Eckhardt (1905–1998) was a Cleveland artist renowned for her glass and ceramic sculptures who had rediscovered the ancient Egyptian technique of making gold glass. This long-lost art was rarely attempted because of the complexities involved in fusing gold between sheets of glass. Eckhardt was an instructor at the Cleveland School of Art (Cleveland Institute of Art), her alma mater of 1931, when she re-created the technology. After numerous experiments, Eckhard perfected the process in 1953 and then was able to use the glass as a medium for sculpture. She was perhaps the only female artist with this skill, and won worldwide acclaim. It was not an easy road for female artists at the time, which is why Eckhardt assumed the name Edris rather than use her birth name Edythe as she fought for a place in the male-dominated world of art. Her big break came in 1933 when, after a period of study in New York, she was tapped to head the Ceramic Sculpture Division for the Federal Arts Project. She had extensive knowledge in all aspects of firing, glazing, and chemistry in her work as a ceramic sculptor, so her selection was obvious. As head of this federal department she taught the art of ceramic sculpture and designed pieces to decorate public buildings, especially libraries and schools. Her series of Lewis Carroll characters was popular nationwide. By 1939, Eckhardt's mastery attracted the attention of First Lady Eleanor Roosevelt, who commissioned a ceramic sculpture of Huckleberry Finn. In 1941, Eckhardt returned to Cleveland, where she taught and won awards for her work in local and national art shows. She has many pieces on permanent display in the Cleveland Museum of Art. She was a pioneer in her field and a fine example for emerging women artists.

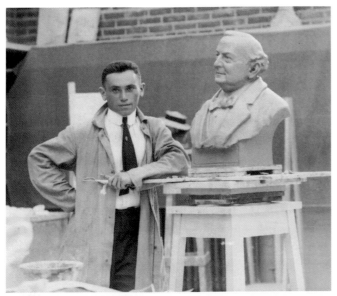

Max Kalish
Max Kalish (1891–1945) was a sculptor renowned for his statues of labor subjects and public figures. Kalish moved to Cleveland with his family in 1898 from Lithuania. He graduated from the Cleveland School of Art (Cleveland Institute of Art) and continued his studies in New York and Paris. Displaying a talent for body sculpting and modeling, he won numerous awards and commissions for his work. Kalish is seen here with a plaster cast of Cleveland mayor Tom L. Johnson, elected in 1901 and a true legendary local.

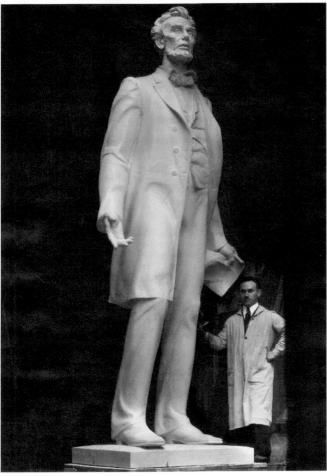

Lincoln Statue by Max Kalish
When deciding how to interpret Lincoln at Gettysburg, Kalish decided to capture him at the instant he completed his famous address. Kalish explained in 1929, "I am certain that in the moment when he finished that inspired message he was in a mood of exaltation, and that he looked ahead and beyond . . . with the vision of a prophet of old." Here, Kalish displays the completed 13-foot-tall plaster cast of Lincoln to be cast in bronze. When completed, Lincoln was placed in front of the Cleveland Board of Education Building, designed by architects Walker and Weeks.

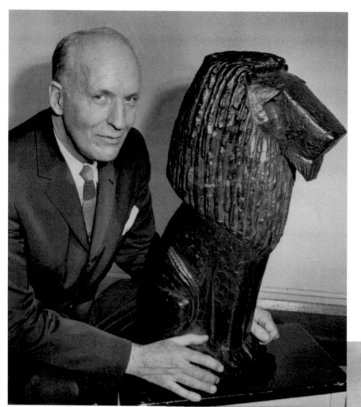

William Mozart McVey
William McVey (1905–1995) was Cleveland's most prolific monument and public sculpture artist. While McVey is not a household name, his works pepper the city, like his grizzly bear at the Cleveland Museum of Natural History or the many bronzes commissioned to honor local leaders and heroes including Jesse Owens and Tom L. Johnson. McVey was the department head of sculpture at the Cleveland Institute of Art, his alma mater (1928), and maintained a private studio at his residence.

Joseph Carabelli
Joseph Carabelli (1850–1911) was a stonemason and artist whose company, The Lakeview Granite & Monumental Works, created some of the most impressive memorial monuments and statuary found in Cleveland cemeteries, especially historic Lake View Cemetery. Carabelli was a northern Italian who moved to New York in 1870 and worked as a stonecutter and sculptor. He then came to Cleveland in 1880 and opened his monument business. As a leader in Little Italy, he made sure to hire skilled Italian immigrants to work as stonecutters and mosaic artists.

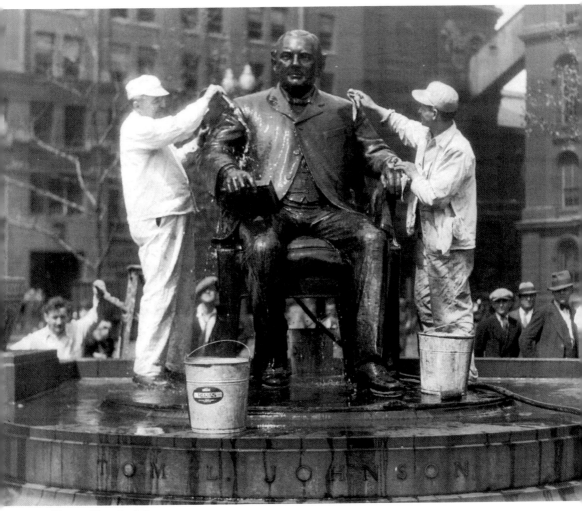

Mayor Tom L. Johnson

Mayor Tom Johnson (1854–1911) was arguably the best mayor to lead the City of Cleveland during its greatest period of growth when it ranked as one of the top five cities in the United States, with a population nearing one million. It was only fitting that such a leader be immortalized in bronze, sitting attentively in the northwest quadrant of Public Square. Johnson was a Democrat and a Progressive who sat as mayor from 1901 to 1909, having won election for three consecutive terms. Growing up poor in Kentucky motivated Johnson to succeed and he became wealthy through railroads, streetcars, and steel, all industries favorable to Cleveland. Herman N. Matzen (1861–1938) was the sculptor commissioned to create the statue of Johnson, which was dedicated four years after the mayor's death. Johnson is portrayed holding a book by author Henry George, who was reportedly his favorite writer. Matzen came from Denmark and trained as an artist in Germany. Settling in Cleveland, he taught at the Cleveland School of Art (Cleveland Institute of Art) and led the department of sculpture. Matzen created many sculptures, which can be found all over the city. The most prominent, however, remains the Johnson statue on Public Square.

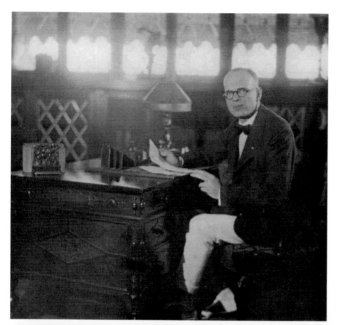

Joseph Laronge, the Father of Playhouse Square

In 1916, local real estate developer Joseph Laronge (d. 1964) had the idea of creating a theater district on Euclid Avenue that would include venues for vaudeville, movie, and stage productions, along with fancy shops, restaurants, and offices. Laronge partnered with Marcus Loew of New York to sell the idea for an entertainment district to theater professionals. In 1921, the first of five planned theaters, the State Theater, opened to enthusiastic crowds. The Ohio Theater, the Hanna Theater, and the Allen Theater opened later in 1921. The last, the Palace Theater, debuted in 1922.

The Cleveland Playhouse: Brooks Theater

Clevelanders are theater lovers, and in 1916 playwright Charles Brooks (1878–1934) led efforts to create the Cleveland Playhouse, on Cedar Avenue, to present bohemian plays for the artsy set. The company is pictured in 1948 in a scene from *January Thaw* featuring (standing) John Beeman, Curtis Paul, Penelope Bebout, Gordon Hatfield, Rolf Engelhardt, and Robert Evans; (seated) Wilda Leslie, Sue Crebaugh, Clarence Kavanaugh, Violet Oakes, and Terry Shean.

Rowena and Russell Jeliffe

Rowena (1892–1992) and Russell (1891–1980) Jeliffe were the cofounders of Karamu House, a settlement house located at East 89th Street and Quincy Avenue that became a widely acclaimed theater house serving the African American community. The Jeliffes were both social workers who combined their love of theater and desire to help others into the creation of an interracial settlement house. They met as students at Oberlin College, graduated together in 1914, and married a year later. They moved to Cleveland to open their settlement house, first known as Playhouse Settlement on East Thirty-eighth Street, until Hazel Mountain Walker, a member and actress in 1924, suggested the name Karamu. Rowena wrote and produced plays using interracial casts, and Russell directed hundreds of plays. By the time the Jeliffes retired in 1963, Karamu House was renowned as a major cultural and educational institution.

The Karamu Dancers

In 1959, the Karamu House Dancers took part in a production called *Jamaica*. Karamu House distinguished itself as an outstanding amateur theater and showcased many up-and-coming local artists who otherwise may not have had an opportunity to perform before an audience. Karamu House offered classes in theater, dance, voice, and visual arts for neighborhood youth desiring to pursue a career in the arts.

The Singing Angels
Founded by career musician Bill Boehm, the Singing Angels have been a presence on the Cleveland music scene since 1964, with the express goal of fostering camaraderie in children through the performance of music. Not only did this chorus gain critical acclaim and widespread popularity locally, but they were in demand nationally and internationally, having performed at the White House and in over 30 different countries, as well as with performers like Bob Hope, who himself started performing as a child while living in Cleveland. With over 100 shows a year, the Singing Angels use their profits and popularity to benefit charity. So popular is the ensemble that what began as an 80-student chorus has now flourished into a 300 member group with a reserve chorus who headline their own concerts annually at Playhouse Square theater. Their expansive repertoire includes classic genres like spirituals and show tunes as well as contemporary pop and barbershop harmonies.

CHAPTER SIX

The Newsies

Many of the figures discussed in this final chapter who have reported on colorful characters in the history of Cleveland are worthy of being in print themselves. We begin with Anna Perkins, "Newspaper Annie," who sold the penny press in her own inimitable style that shocked many at the time. Doris O'Donnell broke down barriers for women in the newsroom and, like her contemporary Theodore Andrica, brought news of the world to our doorsteps. Writers like Grace Izant, William Ganson Rose, Don Robertson, and George Condon published their observations of Cleveland in popular books that no doubt found their way onto the shelves of Anne and Robert Levine's Publix Book Mart. Dr. Ruby Redinger wrote essays that reminded us just how talented Clevelanders are. Louis B. Seltzer, editor of the *Cleveland Press*, and Paul Bellamy, editor of the *Plain Dealer*, strove to produce the finest daily newspapers. Clevelanders had to choose which they subscribed to, and it was not always an easy choice. A small tribute must be paid to the *Cleveland Press* photographers whose images enticed readers to follow the stories behind them. These are the people who told Cleveland's story—the good and the bad—and who hoped to inspire Clevelanders to stay and make the city great once more.

Anna "Newspaper Annie" Perkins

Annie Perkins (1849–1900) was a familiar figure at the corner of Euclid Avenue and Ontario Street as she sold her copies of the penny press. At a time when the only careers for women were teaching, nursing, and domestic work, Annie Perkins made her living selling newspapers. Like the newsies of the day, Annie would scoop up newspapers as they were dropped off by horse-drawn wagons, glance at the headlines, and in her trademark piercing, nasal-toned voice, shout the news. It was believed that Annie was the first woman in Cleveland to wear men's clothing. Once she was arrested by police because she was not wearing a dress. Her work attire consisted of short white pants, a boy's jacket and shirt, heavy white stockings, and sturdy shoes, all topped off with a white cap. Annie lived a spartan-like existence on the West Side, renting an apartment on Detroit Avenue and writing poetry. Although she barely made enough to get by, she managed to help her neighbors in need.

Annie Perkins, Feminist
In 1900, "Newspaper Annie" is standing on the corner of Ontario and Public Square facing north. For years, she was a familiar figure who sold newspapers for a penny and poems of her own composition for 2¢. A freethinker, she expressed it in her manner of dress, considered radical for the time. In both summer and winter, she wore white. She had a *Cleveland Press* bag slung over one hip and her poems on long sheets carried over her arm. (Cleveland Public Library Photograph Collection.)

"What Is It?" A Poet in Newsboy's Clothes
In 1883, Annie published a book of poetry in which she tried to answer the question "Is it man or is it woman? / It is this perplexes us—this perchance that vexes us. Garments make not man or woman / Grand old Nature makes the human / Costume never should impede, but conform to human need. Sack and trousers is the suit—all objections I refute."

Doris O'Donnell: Reporter at Large

Doris O'Donnell (b. 1921) worked as an investigative reporter for several papers, including the *News-Herald*, the *Plain Dealer*, and the *Cleveland News*. A native Clevelander, O'Donnell's passion for journalism began in high school when she was a reporter for the school newspaper. She graduated from Cleveland College, the downtown campus of Western Reserve University, in 1944 and began working as a reporter for the *Cleveland News*. Journalism was not always welcoming to women, but O'Donnell was intelligent and determined. Her goal was to prove that a female reporter could get the scoop just as well as any male counterpart. In 1956, the *Cleveland News* sent her to the Soviet Union to report on life in Russia. It marked the very first time a female reporter of Cleveland had ever been sent on assignment behind the Iron Curtain. Her visa limited her stay in Russia to two weeks, but she made the most of her brief time and covered stories about the people, their schools, hospitals, factories, and all other facets of day-to-day life in a communist country. The stories O'Donnell told were riveting. When not reporting from abroad, O'Donnell would cover the police beat, civil and criminal courtrooms, juvenile court, and welfare. Her feature stories won her awards from the Cleveland Newspaper Guild and the Ohio Newspaper Women's Association. O'Donnell wrote *Front Page Girl*, her memoir, chronicling her impressive 60-plus years in the news business. O'Donnell has not let retirement slow her down. She continues to write and remains a splendid example to any young motivated woman what passion and hard work can achieve in a lifetime.

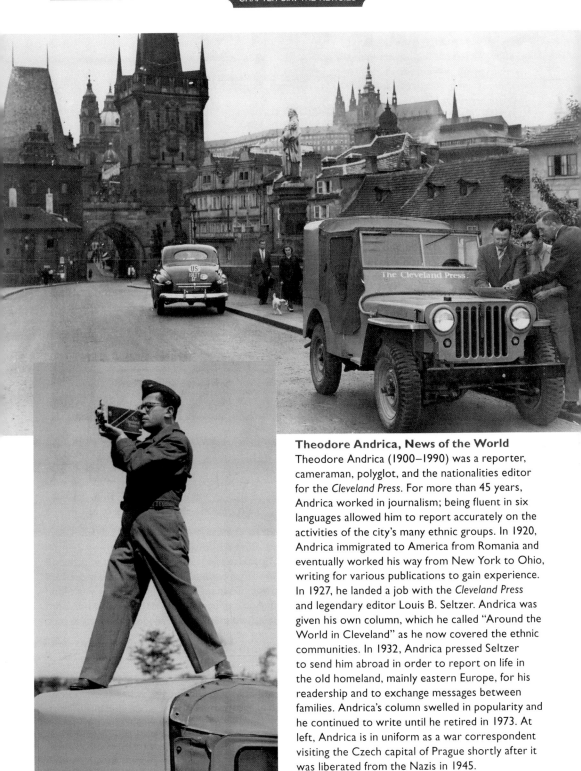

Theodore Andrica, News of the World

Theodore Andrica (1900–1990) was a reporter, cameraman, polyglot, and the nationalities editor for the *Cleveland Press*. For more than 45 years, Andrica worked in journalism; being fluent in six languages allowed him to report accurately on the activities of the city's many ethnic groups. In 1920, Andrica immigrated to America from Romania and eventually worked his way from New York to Ohio, writing for various publications to gain experience. In 1927, he landed a job with the *Cleveland Press* and legendary editor Louis B. Seltzer. Andrica was given his own column, which he called "Around the World in Cleveland" as he now covered the ethnic communities. In 1932, Andrica pressed Seltzer to send him abroad in order to report on life in the old homeland, mainly eastern Europe, for his readership and to exchange messages between families. Andrica's column swelled in popularity and he continued to write until he retired in 1973. At left, Andrica is in uniform as a war correspondent visiting the Czech capital of Prague shortly after it was liberated from the Nazis in 1945.

Anne and Robert Levine, Publix Books
Robert and Anne Levine (center) were the co-founders of Publix Book Mart, an independent Cleveland bookstore that specialized in used and rare books and music. When the Levines opened their first Publix bookstore in 1936 on Prospect Avenue in downtown Cleveland, it was a small business with only a few thousand titles. But the affable manner of Anne and Robert, coupled with their desire to satisfy the hunger of the bibliophiles patronizing their shop, led them to move to a larger store. After 10 years, their second Publix bookstore opened on the corner of Prospect and East Ninth Street, a more visible location. For the next 30 years Publix, with over 100,000 volumes, offered an eclectic collection of books as well as music and art. In 1972, the popular Publix was forced to close when the city needed the land for a new parking garage and the Levines could not find a suitable place to relocate. But not for long. Customers rallied to keep Publix open and the Levines abandoned retirement and moved the store to its third and final home at 1310 Huron Road in the Playhouse Square district. Finally, in 1978, the Levines retired and sold Publix Books.

Grace Goulder Izant

Grace Izant (1893–1984) was a columnist for the *Plain Dealer Sunday Magazine*. Izant's column, "Ohio Scenes and Citizens," was published from 1944 to 1969 and highlighted the places and homespun personalities distinct to Ohio. In 1964, Izant reproduced her best articles in book form. She also authored her first book on Ohio history, called simply *This Is Ohio*, in 1953, providing brief histories of every Ohio county. *John D. Rockefeller, The Cleveland Years,* published in 1972, was her second book and proved her talent for writing history. Izant received many awards for her fine work.

William Ganson Rose

When William G. Rose (1878–1957) wrote *Cleveland: The Making of a City* in 1950, it was the most comprehensive history to date on Cleveland. Ganson organized the 1,200 page tome in meticulous chronological order, following the growth of the city and the lives of its notable citizens year-by-year. Before he turned to writing history, Rose worked as the drama editor for the *Plain Dealer.* He then turned to advertising and opened his own company, which he used to promote Cleveland's growth and raise civic pride. Rose had been a member of the City Planning Commission and many other civic organizations, so when it came time for him to write his book, he knew his hometown and its population very well.

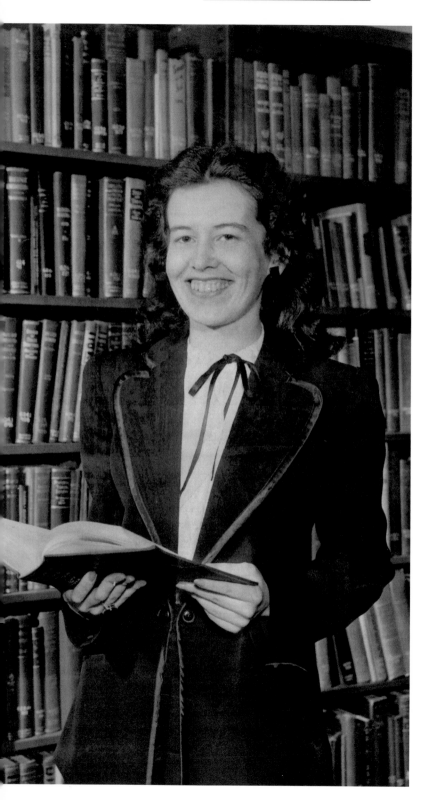

Ruby V. Redinger
The Golden Net, the first book by Ruby Redinger (1915–1981), was published in 1948 and established her as one of the finest new authors of her day. Redinger wrote about all aspects of university life, something she was familiar with as a college student and then as an English professor, first at Cleveland College and then Fenn College. Dr. Redinger penned her first book at Fenn, for which she received critical acclaim. In 1948, she chaired the philosophy department at Fenn and left after two years for a faculty position in the English department at Baldwin-Wallace College. During her nearly 30-year tenure at Baldwin-Wallace, Dr. Redinger completed her second book, *George Eliot: The Emergent Self.* Published in 1975, it was called the definitive work on Eliot. She received numerous awards for her work and retired from teaching in 1980.

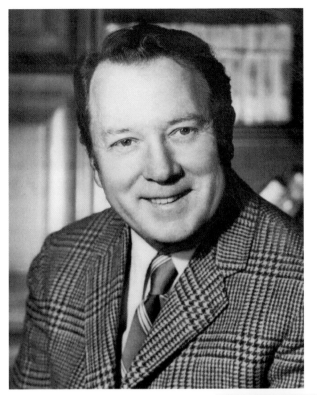

George E. Condon

George Condon (1917–2011) was a journalist who authored several books on Cleveland and its environs including *Cleveland, The Best Kept Secret* in 1967, and *Yesterday's Cleveland* in 1976. In 1943, Condon found work as a reporter with the *Plain Dealer* and, in 1962, was given his own opinion column to write, which he did for the next 20 years. Condon received numerous awards for his work and, in 1990, was inducted into the Journalism Hall of Fame.

Paul Bellamy

Clevelander Paul Bellamy (1884–1956) was a long-time editor of the *Plain Dealer*, holding the position for over 25 years, and he also held the distinction of being the youngest editor for the daily when he began in 1928. Bellamy joined the paper upon graduating from college, working first as a beat reporter and working his way up to city editor. World War I called him to duty but when he returned, he was promoted to managing editor and finally editor, a position he held until his retirement in 1954. Bellamy could be controversial as the daily head, and he enjoyed competing with the other papers for a good story, particularly the *Cleveland Press*. Bellamy received many citations for his work as editor.

Louis B. Seltzer: "The Years Were Good"

Louis Seltzer (1897–1980) was a native Clevelander and the 38-year editor of *The Cleveland Press*. Seltzer quit school at age 12 to find work as a reporter and writer. In 1912, he was hired by *The Cleveland Press* to follow the police beat. Following a period as the political editor, Seltzer was named editor in 1928 and remained so until 1966. Seltzer believed strongly that newspapers should give back to the communities who kept the papers thriving. He became active in civic, charitable, and political affairs. He realized the power of the press in making or breaking a political candidate and was dubbed "The Kingmaker." In 1956, Seltzer wrote *The Years Were Good*, a memoir chronicling his rise from obscurity to prominence through hard work and dedication to his craft. Seltzer is seen opposite posing next to a bust of Edward Willis Scripps, the founder of *The Cleveland Press*.

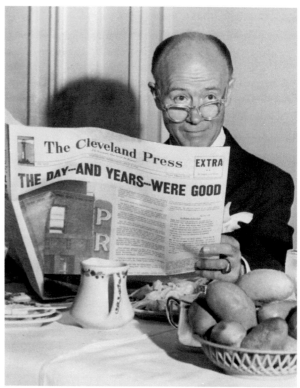

Don Robertson: "The Greatest Thing Since Sliced Bread"
Author and journalist Don Robertson (1929–1999) wrote for the *Cleveland News*, the *Cleveland Press*, and the *Plain Dealer* and penned nearly 20 books. He was a graduate of East High School and served in the US Army during World War II. Following wartime service, Robertson attended Harvard but left after a short time as he could not abide the snobbery. He transferred to Case Western Reserve University, where he became editor of the school newspaper but left when he refused to be censored. He had been a copy boy for the *Plain Dealer* and his parents also worked for the daily. His mother was one of the first female reporters and his father had been the travel editor, so Robertson was something of a legacy when it was his time to work for the paper. Robertson did not limit himself to newsprint and made frequent appearances on local television and radio shows. But his real passion was writing his novels. According to his wife of 12 years, Sherri, "Don was very excited when a new book of his was about to be released. In fact, he had a heart attack on the day that *Praise the Human Season* was released and a stroke on the publication date of *Prisoners of Twilight*. He loved his novels and he loved writing them. I think writing them kept him alive. His favorite book was *Miss Margaret Ridpath and the Dismantling of the Universe*. I think he found covering the Sam Shephard trial to be compelling." Robertson had a talent for using fiction to chronicle some of the more tragic events in Cleveland's history. He wrote a trilogy of novels, the first of which was *The Greatest Thing Since Sliced Bread*, published in 1965, which told the story of a fictional boy named Morris Bird III and used the East Ohio Gas Explosion of 1944 as the setting. To complete the trilogy, Robertson wrote *The Sum and Total of Now* and *The Greatest Thing That Almost Happened*. He received numerous honors and awards, including induction into The Press Club of Cleveland's Hall of Fame. Robertson loved Cleveland and was immensely popular. He had a huge fan base, as seen here as he stands before a sampling of his fan mail. He was an amazing person.

"Say Cheese!" The Press Boys, 1974

The *Cleveland Press* built its reputation not only on the written word but also on the images taken by these award-winning photographers, without whom this publication, for one, would not have been possible. They are (clockwise) Fred Bottomer (seated at center), Herman Seid, Larry Nighswander, Van Dillard, Tim Culek, Frank Reed, Tony Tomsic, Paul Toppelstein, Bernie Noble, Bill Nehez, Clayton Knipper, and Paul Tepley.

INDEX